Not Here. Not There.

DEWI LEWIS
PUBLISHING

First published in 1998
by Dewi Lewis Publishing
in association with PhotoForum Inc,
Galerie Esther Woerdehoff and Photology

Dewi Lewis Publishing, 8 Broomfield Road,
Heaton Moor, Stockport SK4 4ND, England.
Tel: 0161 442 9450

PhotoForum, P.O.Box 5657, Wellesley Street
Auckland, New Zealand.
Published as PhotoForum number 62 & 63

Galerie Esther Woerdehoff, 36 rue Falguière,
75015 Paris, France. Tel: 33 1 43 21 44 83

Photology, 24 Litchfield Street, London
WC2H9NJ, England. Tel: 0171 836 8600

ISBN: 1 899235 76 0

Edited and designed by Harvey Benge
Text set in Futura
Printed by Condor Productions, Hong Kong

With the generous support of
Creative New Zealand

Photographs by Harvey Benge

Peter Turner

I would like to introduce you to Harvey Benge, photographer. Not in the standard biographical way as an artist who has "been there and done that". Harvey is quite capable of self revelations himself. Indeed this work stands as a further volume in an autobiography that began with the publication in 1993 of "Four Parts Religion, Six Parts Sin". Further, writing about the person is to divert attention from the work, and I know Harvey would rather you looked at the pictures than concern yourself with his date of birth, education and all those other incidentals that make up a Curriculum Vitae. But let it be said that Harvey is a well established member of New Zealand's photographic community and part of an international movement toward the legitimate use of colour as part of the make-up of a considered photography. (Should this last point seem incidental let me remind you that photography's history has been written mainly in back and white.) To make a "considered" photograph requires – in different degree – vision, tenacity, intelligence, some technical skill and a willingness to put oneself "on the line", to be openly curious and frank about the sometimes unlikely places this passion for gazing at the world can push and pull one towards. This is why I say that this work is autobiographical. It stands at once as a personal reflection of the world while being an examination of it. The pictures shown here record Harvey's personal travels and observations, his street roaming in Europe and New Zealand and the elliptical glances this has provoked. What we are offered stands more as a succession of questions than a series of neat answers.

I will return to this idea. Meanwhile, another generalisation: these pictures display another very desirable quality, finesse – a quality of seeing, feeling, responding. That is, they result from a careful look not just at what is there, but what it might mean when placed within the context of what we call photography.

In our role as viewers we should ask why did Harvey want to travel, observe and examine? Then, what separates these pictures from those produced (in all good faith) by a tourist? Finally, where might such images fit within the panorama of photography?

Why Harvey chose to travel is a clue to why his pictures might interest us. Possibly it is to do with a residual insecurity and some sense of isolation from the world that inevitably influenced the New Zealand

psyche. Insecure because I suspect we still suffer from hazy feelings of not being quite national enough, induced by our historical "overseas" mind-set with a little bit of English, Scottish, Irish, Welsh, Scandinavian, Dutch, Dalmatian, Italian, German, and so on lingering in the heart. A polyglot European community soldered onto a Polynesian one. Going back to Europe is still for some a rite of passage. An act of liberation. New Zealand is a small country that constrains its citizens to perform within undefined but internally understood parameters. Breaking away and going away is good for the soul and even better on the eyes. But Europe might not be the place that was expected. This is what Harvey has pictured – the unexpected.

His wry and sometimes acerbic view is not confined to Europe. His home town of Auckland, New Zealand's largest city, does not escape his gaze. On the one hand his vision has to do with the everyday, on the other with the myriad of visual incidentals that make up our world: dazed, confused and fascinating.

This notion is the point of examination. Which is about looking at the ways we have shaped and moulded our often curious environment. These pictures show that their maker refuses to accept face values. We are looking here at sights, sites and signs, no easy task in a world burdened by persuasion. "Do this, buy that and aspire to the next purchase" is the overriding message in a free-fall world that aspires to pre-payment funerals alongside the time honoured means of making one feel inadequate about how white your teeth might be. Within such a scenario Harvey asks, quite directly, "Do I really have to?" His response is at once visceral, visual and entertaining, a consumer's guide to contemporary foibles of the urban kind. Such scepticism is written in the language of enquiry and poses questions that most tourists care not to ask as they parade in Martin Parr-like tableaux in cities around the world. So Harvey applies some visual intelligence to the matter, by being a hunter and a gatherer with a camera, and going in search of cityscape insanity. Not, I should add, the barking mad kind of looniness that drives some photographers to make extreme but generally facile statements for fear that some otherwise innocent viewers might miss their points. Harvey's is an altogether more gentle, more tender form of punishment for the silliness that surrounds us. Yet it has its barbs. He lets his intelligence show.

It is this then that you might consider when wondering why someone might point their camera in this

particular direction at that particular time and go on to make a memorable image from a sight you may not have seen. What seems more important is the probability that you didn't see it but Harvey did. He is sending signals about a view of the world that are as useful as any made by an artist who has acuity of seeing and a sense of purpose. Signals? Seeing? Thinking? Reacting?

Am I asking too much? I think not. The art of photography lies in a way of perceiving things much as any artist might. But, of course, all disciplines have edges, boundaries. To advance we must break these down – not as monocentrics nor even consumercentrics but as polycentrics. The embrace of a broad cultural sweep. So let me present not only Harvey Benge, but a couple of his partners in cultural crime.

One, Raymond Carver, is a writer, whom we might term a "precisionist". The other, Eric Satie, is a composer whom we might consider a "colourist". These are both expressions that might apply to the works in this book. Carver, an American, considered the look of things – he was an accumulator of small details that could be used to tell large stories. Satie was French and delighted in the absurd. He owned twelve identical velvet suits and one hundred umbrellas, was a friend of Picasso and Jean Cocteau and wrote music that was designed not to be listened to. If you can imagine a fusion between the senses of exactness (Carver) and a colourful vacancy inspired by Dada (Satie), you will see why I bring these artists into my consideration of Harvey Benge. I look at the work and recall Carver's first book "Put Yourself In My Shoes" published twenty years ago. I can hear these photographs make the same invitation. I can hear too Satie's "Furniture Music", playing in the background and creating a seductive tapestry of sound.

Observations of this kind are not meant to detract from Harvey's own originality, more to draw attention to his immersion in a rich cultural broth. Just as Carver once wrote a marvellous short story, "Cathedral", about what blind people look at, and Satie composed an hilarious piece of music, "La Belle Excentrique", so these photographs take us in their own directions. Which are individual. That point all the while to Harvey's talent as a navigator, mapmaker and scrutineer of those things that most of us overlook.

Kodak once used the phrase "It's as simple as blinking" in their advertising, a phrase which may be true.

What happens when your eyes are shut and your mind is closed?

Harvey shows us.

You may have guessed that I like photographs, yet there are many things that pictures like this do not do. They are not good, for example, at tidying up loose ends – it is probably better that these are left dangling to become matters of the heart. So, photographs, street photographs at least, become a matter of fact and a case of the photographer's enquiry. Or should I use the word curiosity? This said, looking at a collection such as we have here, I am persuaded that photographs make more fiction out of fact – Raymond Carver's gift – and produce an insistent melody of sound while remaining resolutely silent, which is what we find in Eric Satie's music. The first quality asks us to consider concepts, the second wants us to listen. Harvey demands that we look – casually at first but then with more care. He wants us to catch the sound of the city, the way the city is, for all its heritage, tumble-down – and re-assemble it. He wants literature and music for his pictures, along with architecture, painting, sculpture and any other expressive medium you might care to mention.

Make no mistake. Two-dimensional transcriptions of a noiseless, fragile world that lacks motion, which is what photographs generally are, are worth our attention. It's a weird world out there and we should wonder at it while being glad that Harvey Benge has his eyes open, maintains a nimble mind and knows which way to point his camera.

Peter Turner, Wellington, 1998

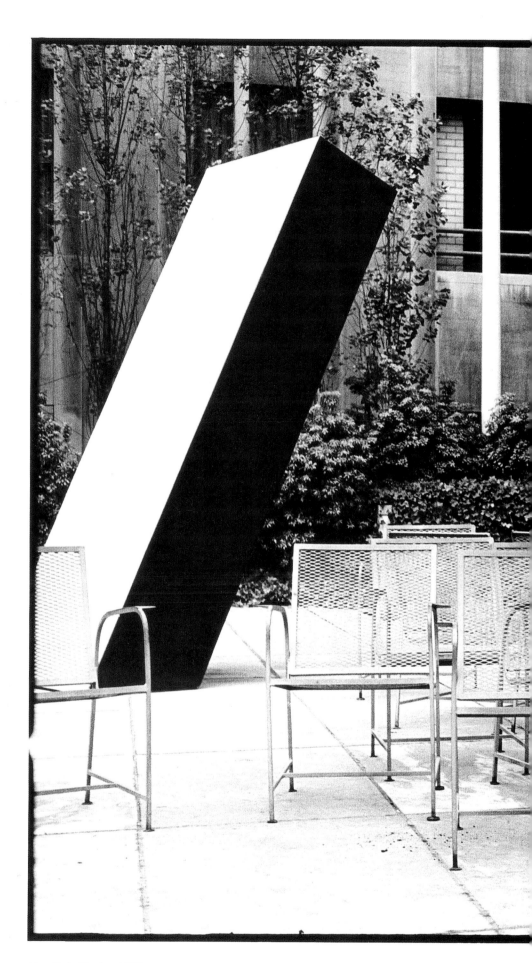

New York, October 1970

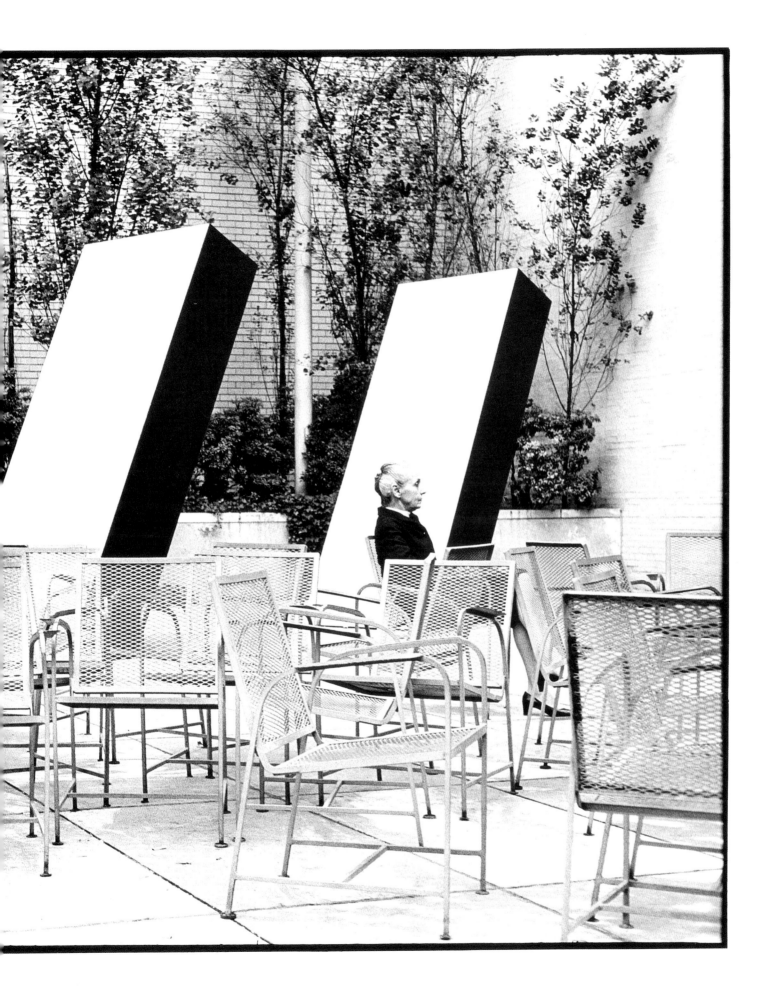

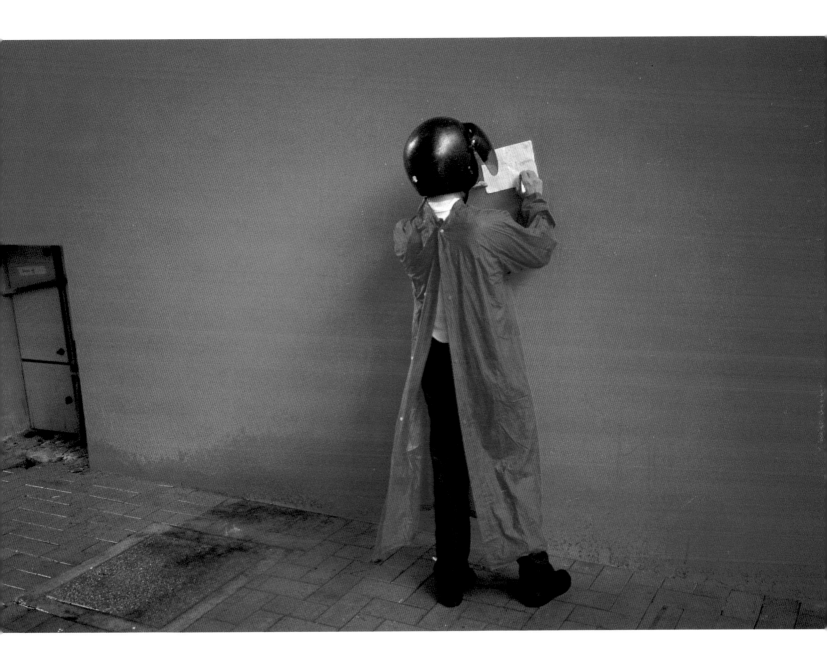

Singapore, October 1996

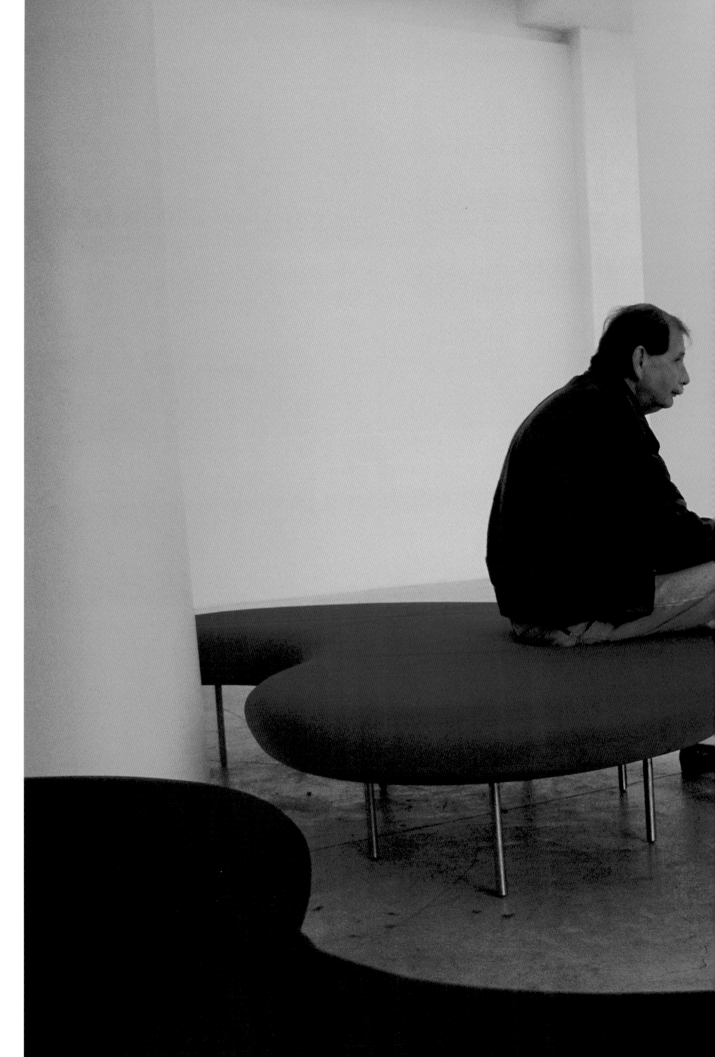

Auckland,
June 1996

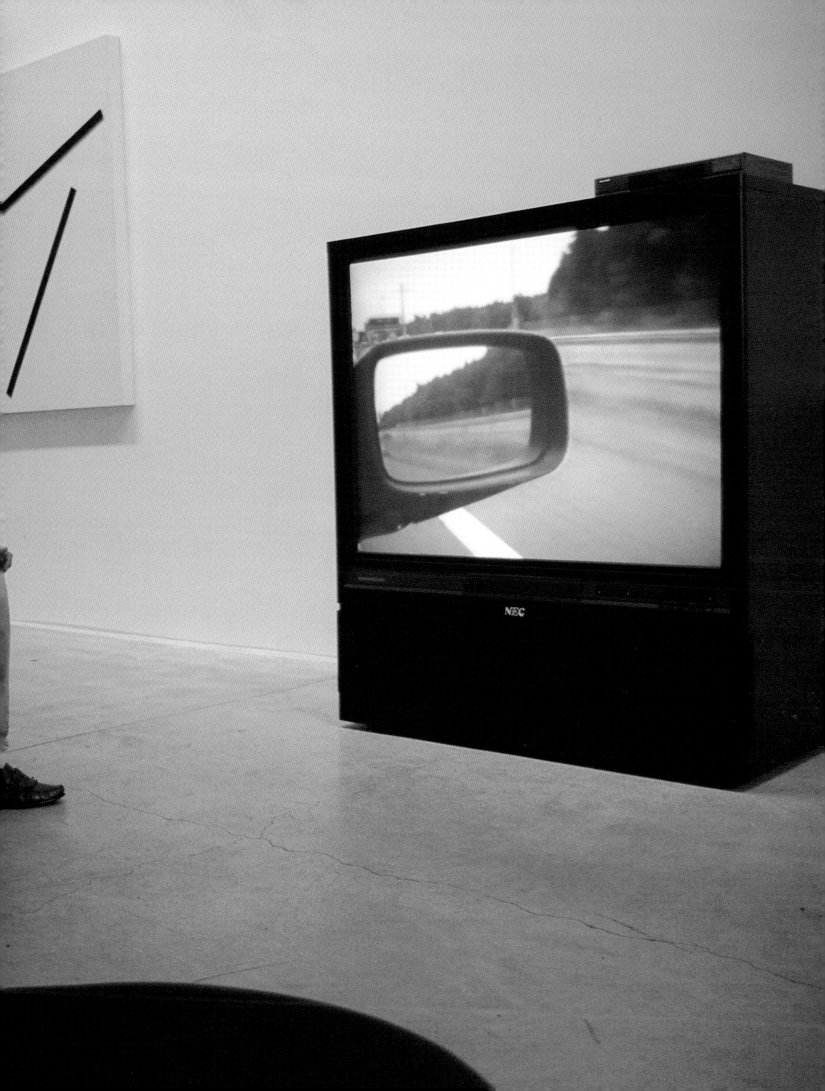

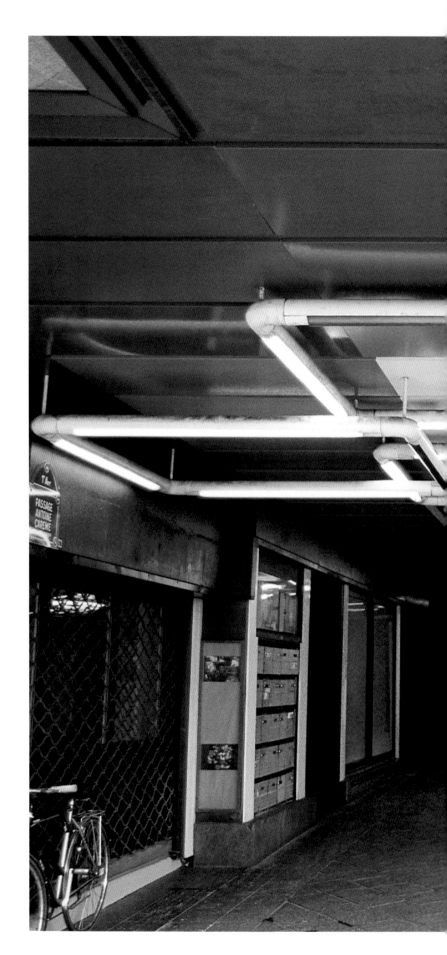

Paris, October 1996

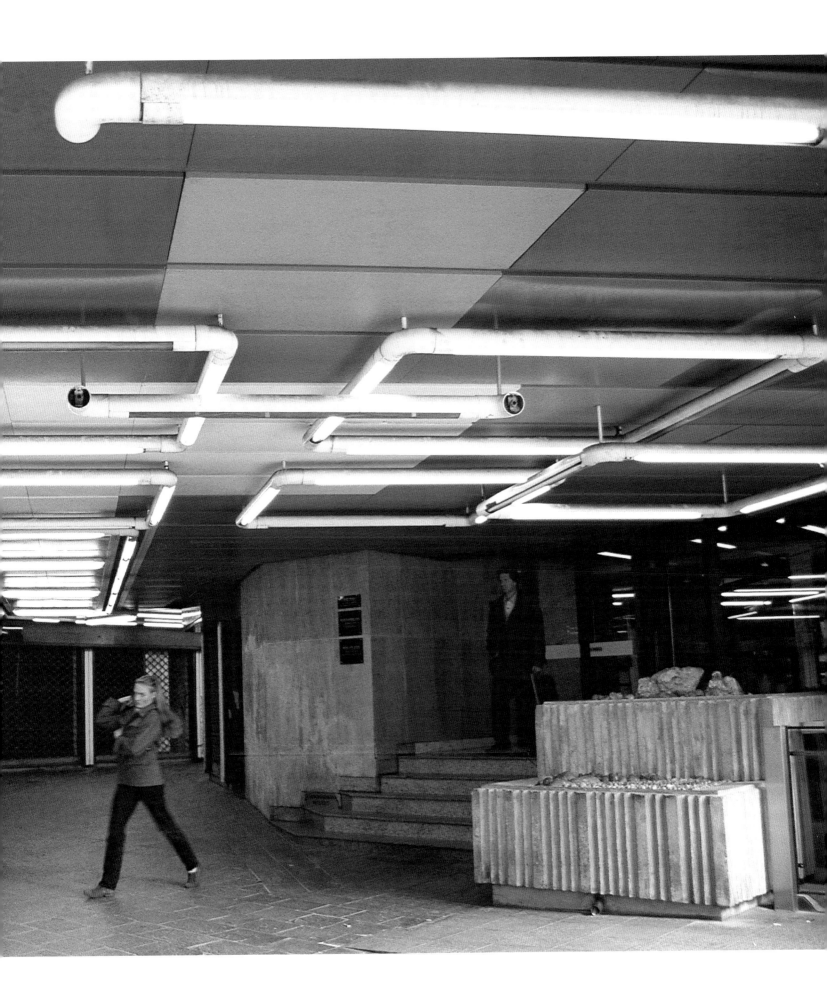

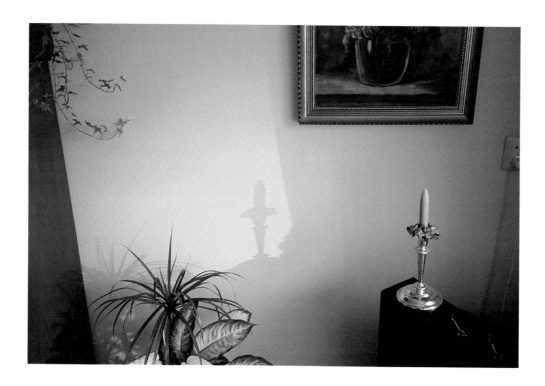

Amsterdam, December 1994

Melbourne, October 1994

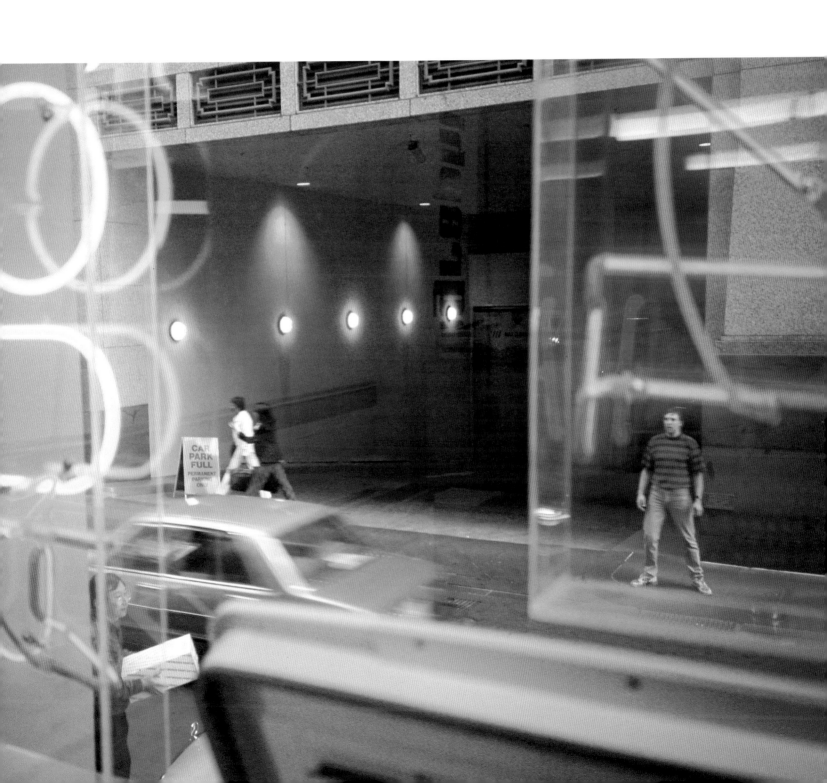

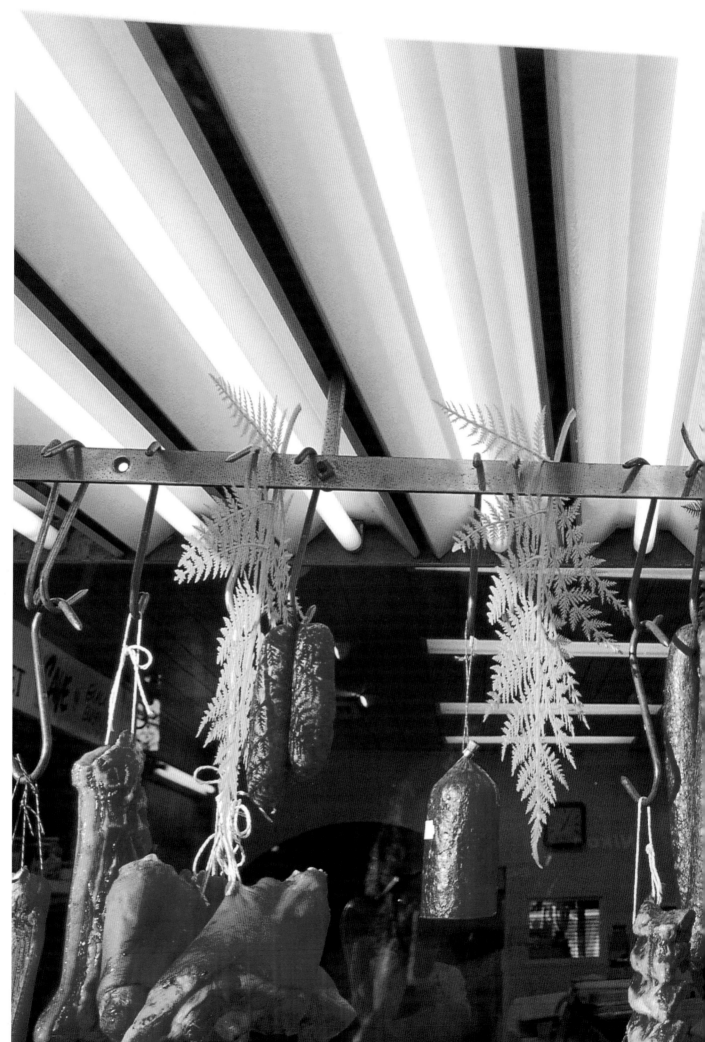

Sydney,
August 1996

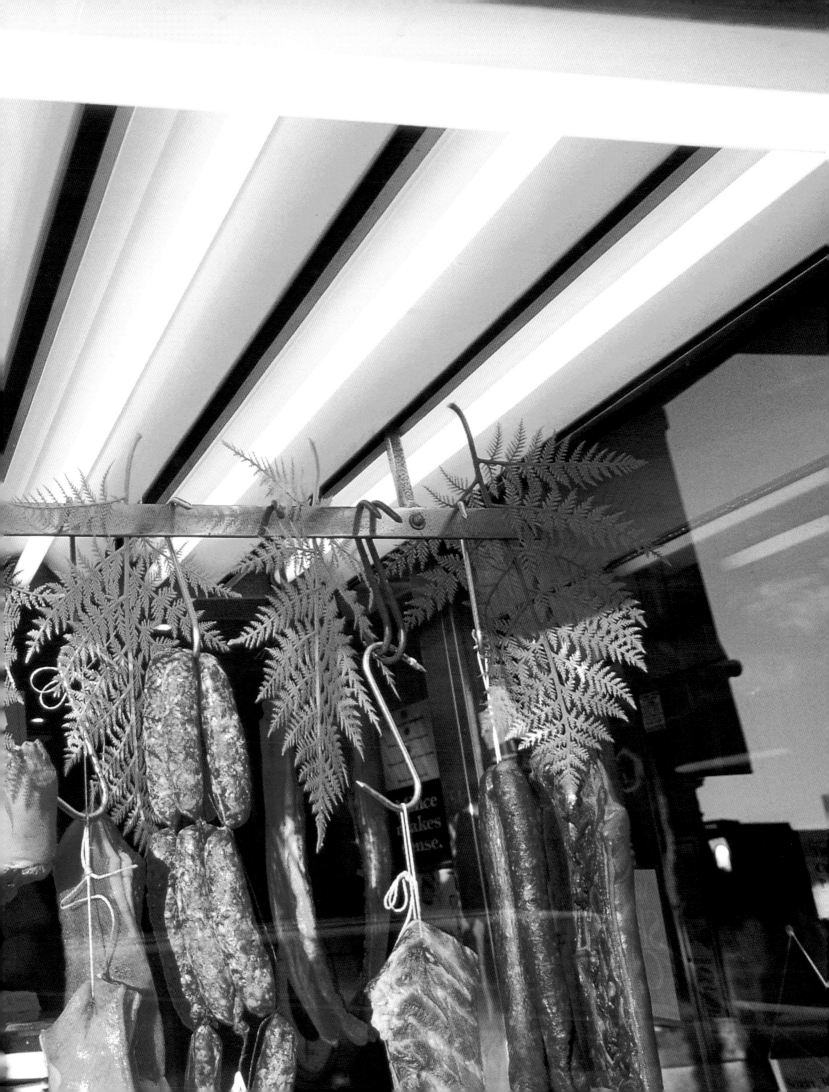

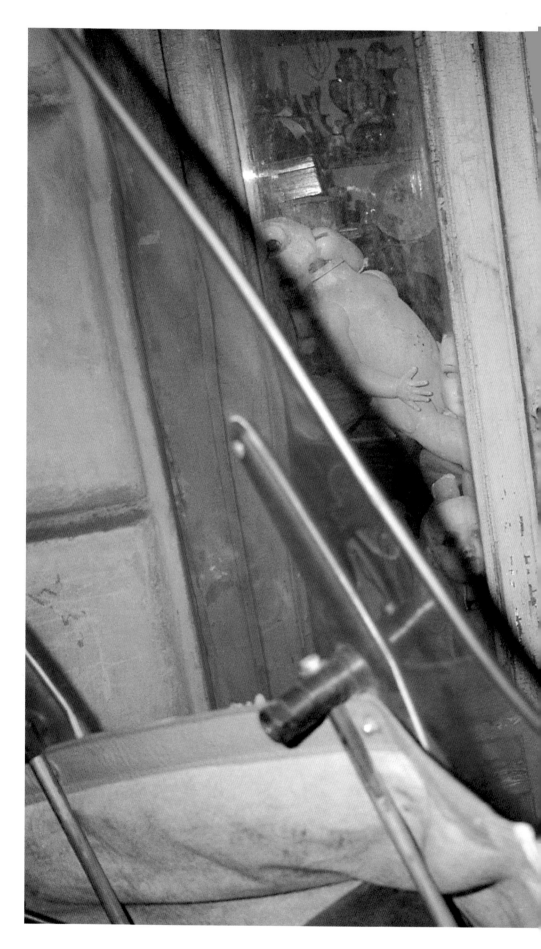

Rome, December 1994

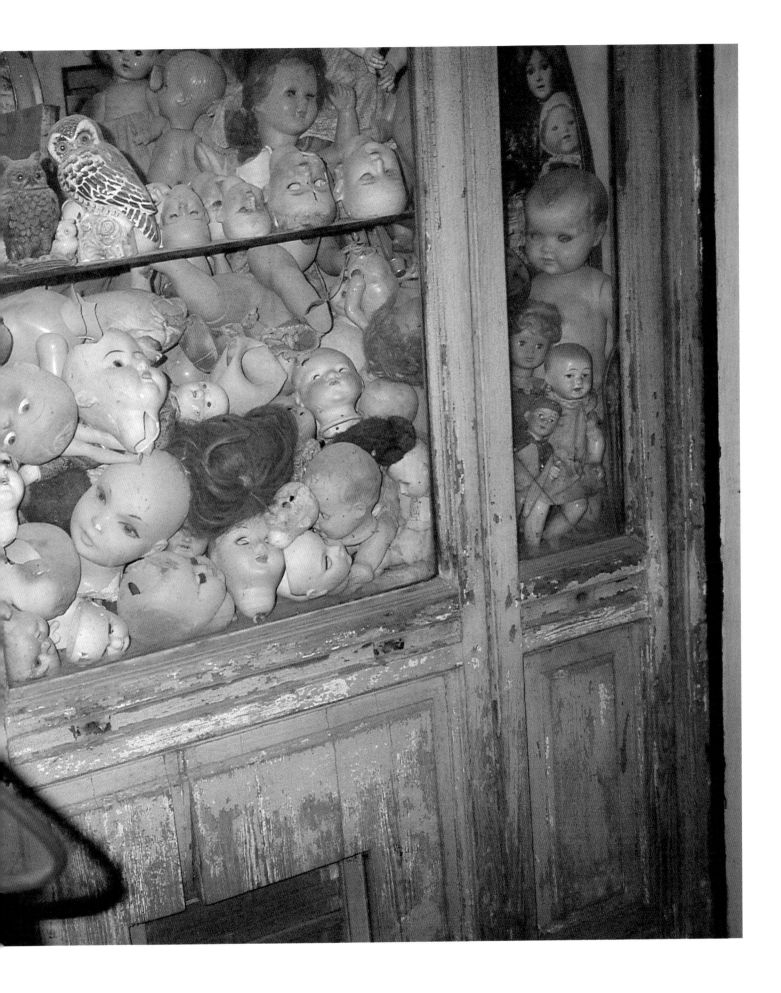

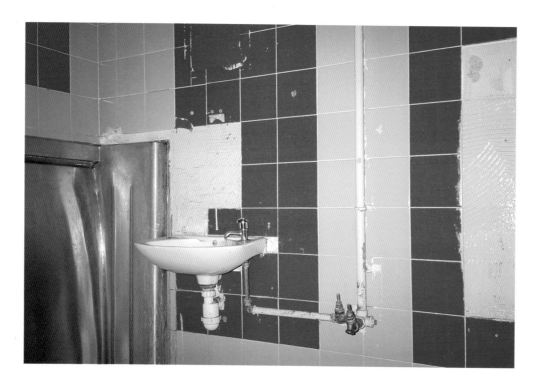

London, December 1994

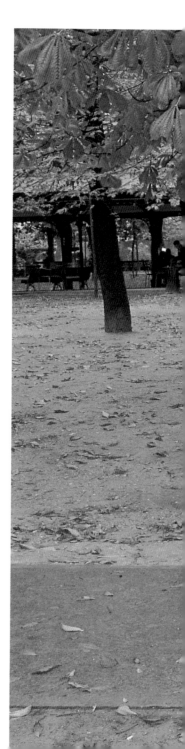

Paris, October 1996

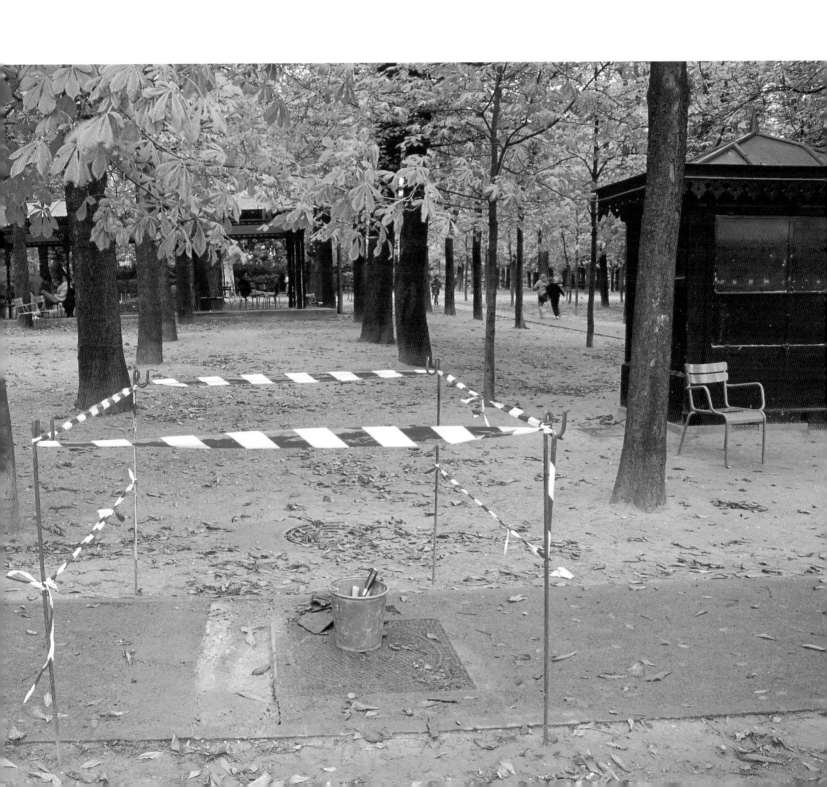

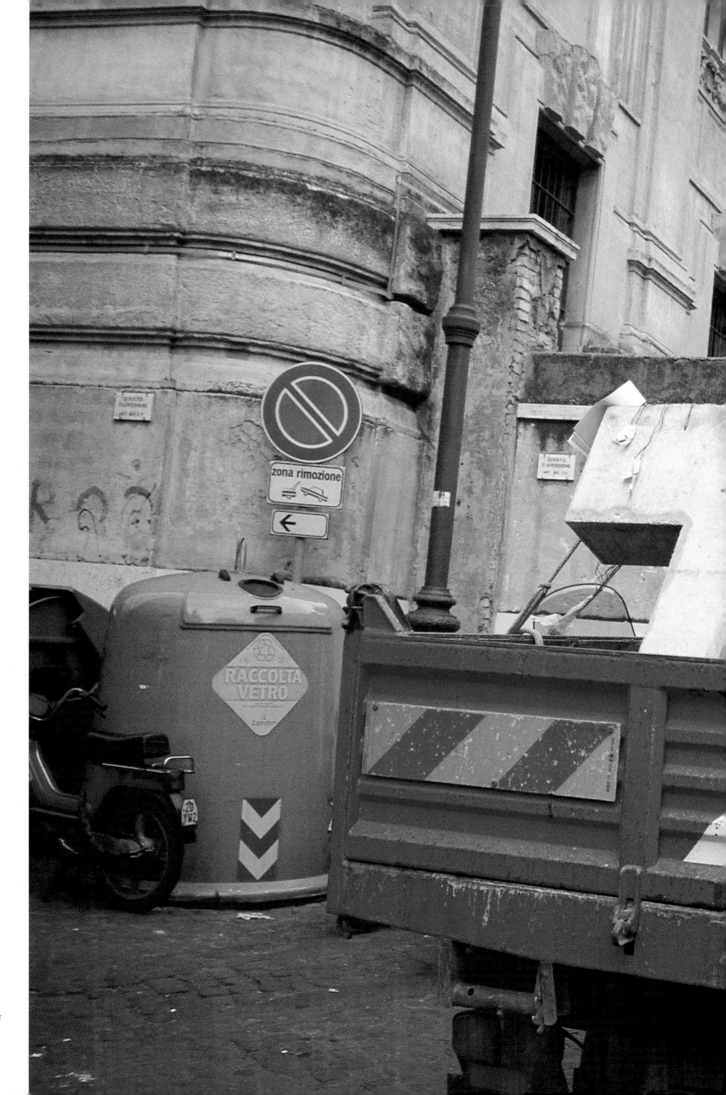

Rome,
December
1994

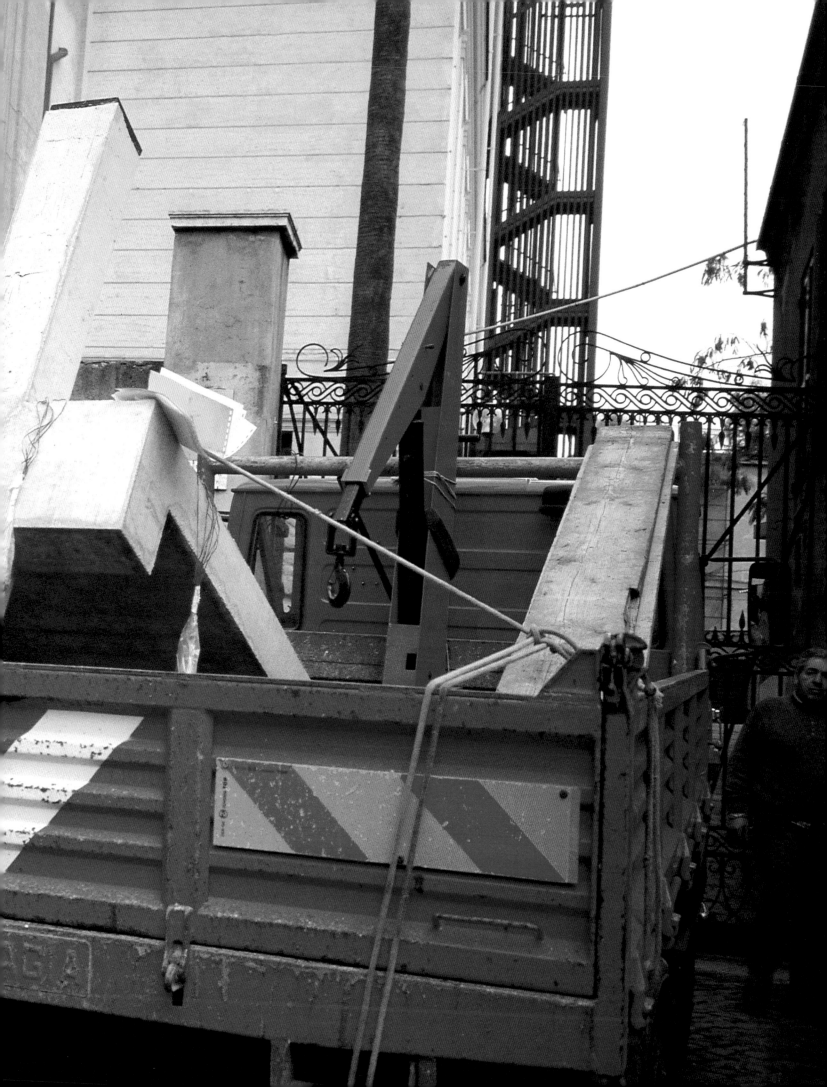

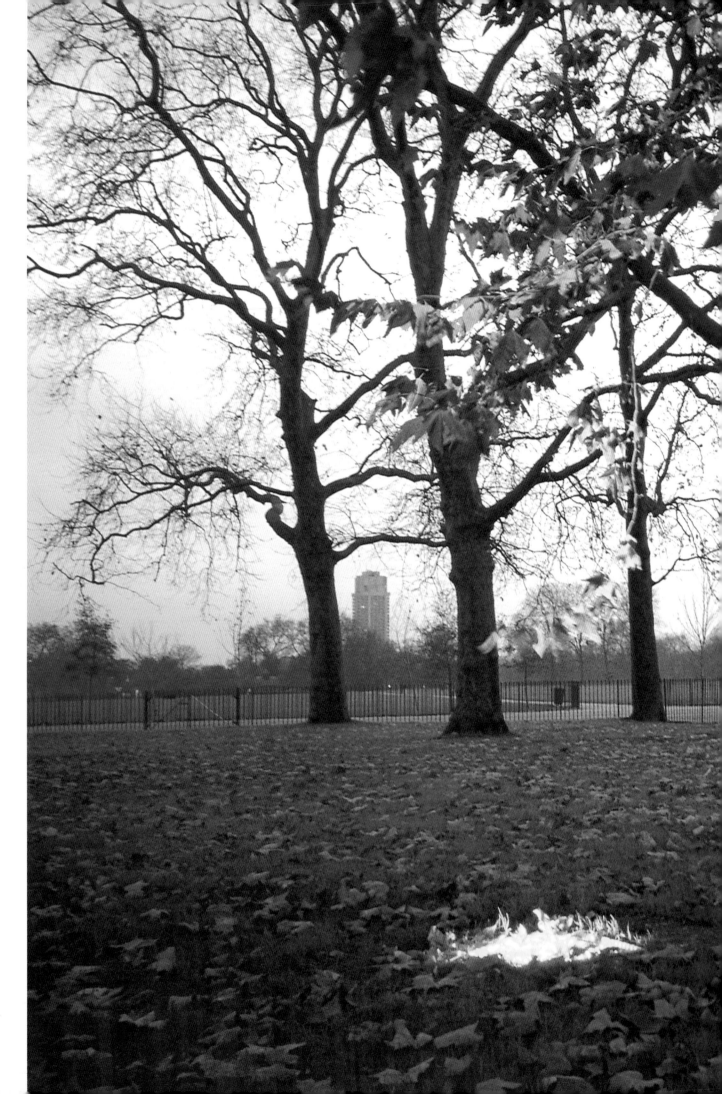

London,
December
1994

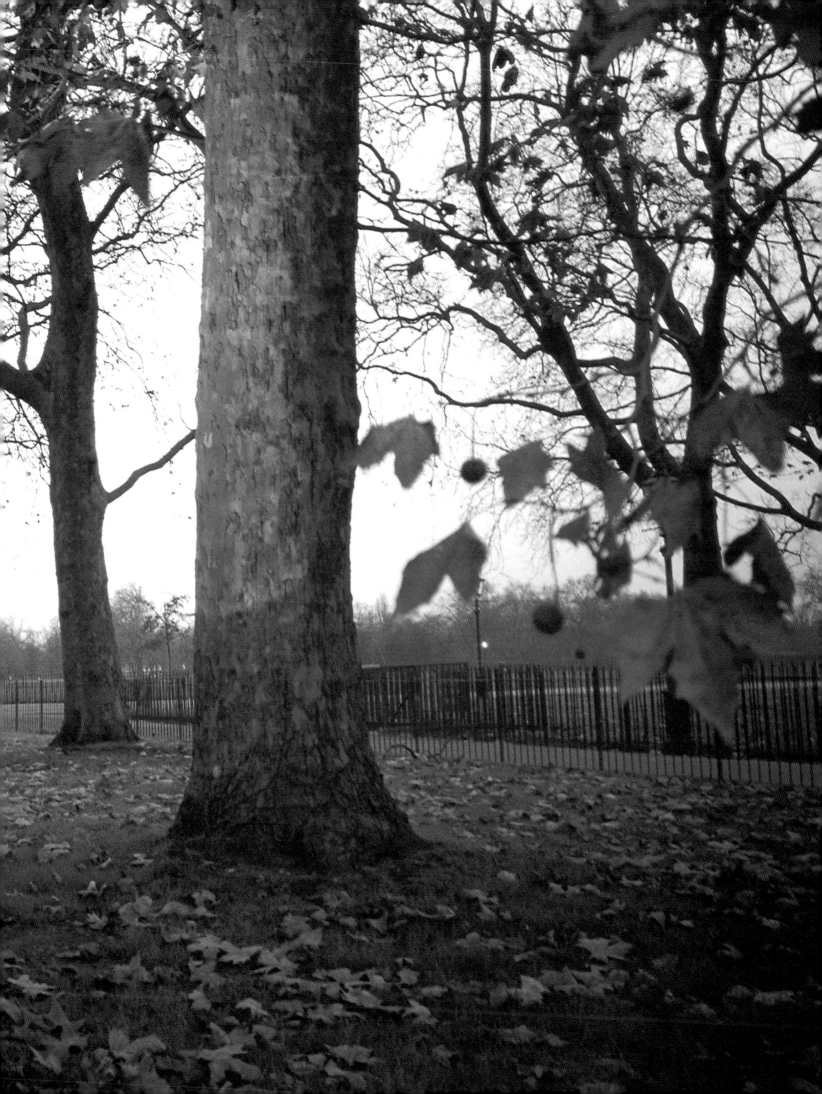

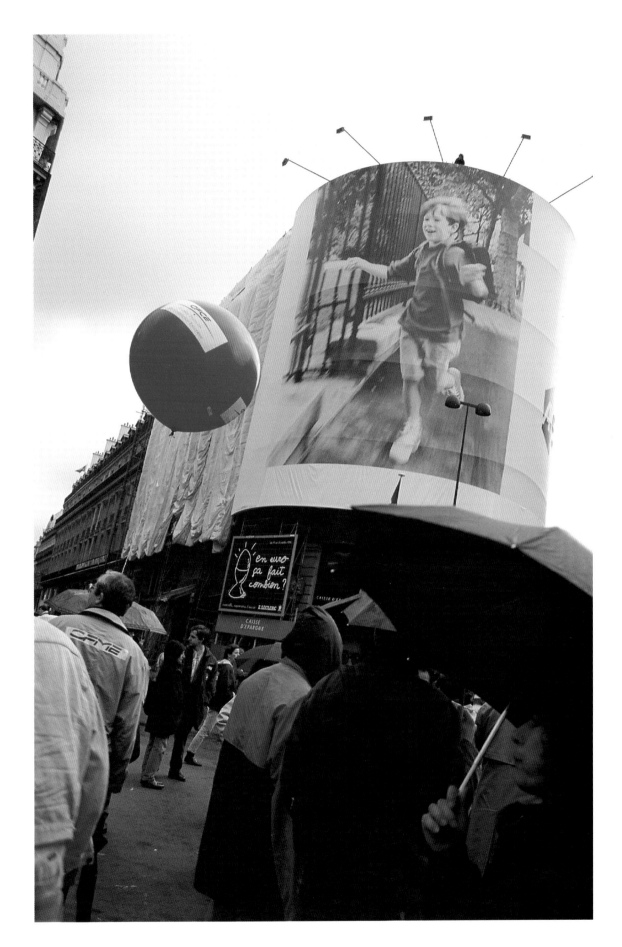

Paris, October 1996

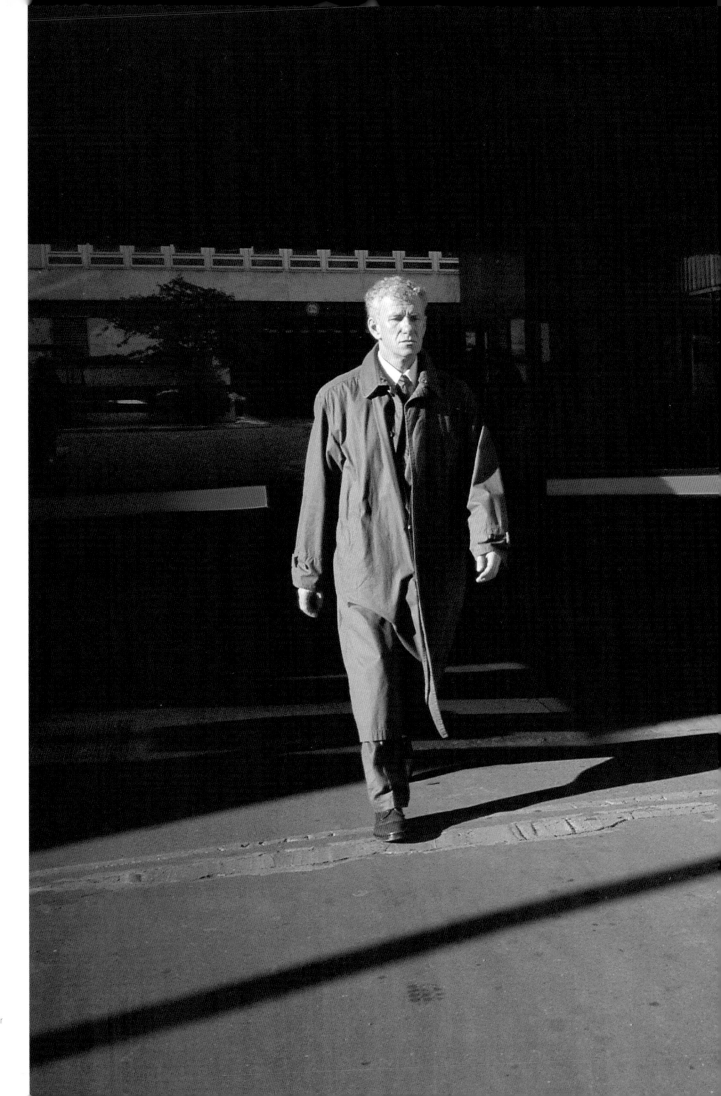

Paris,
November
1995

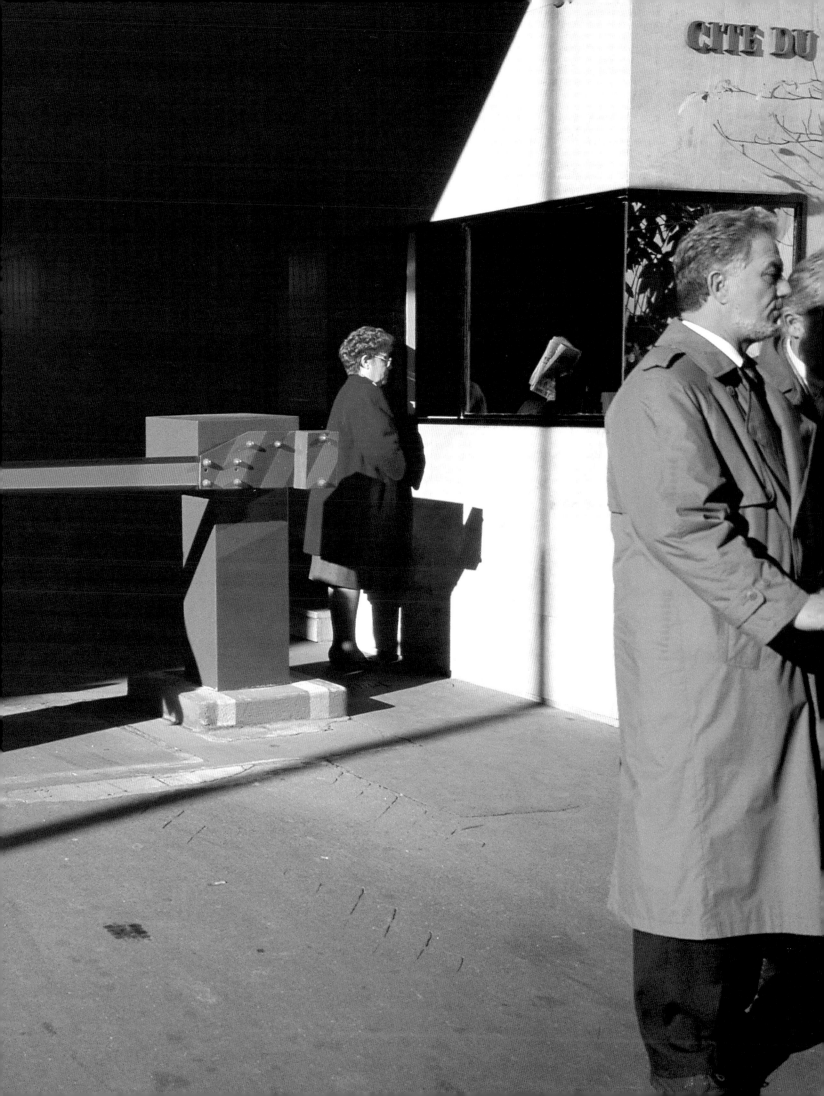

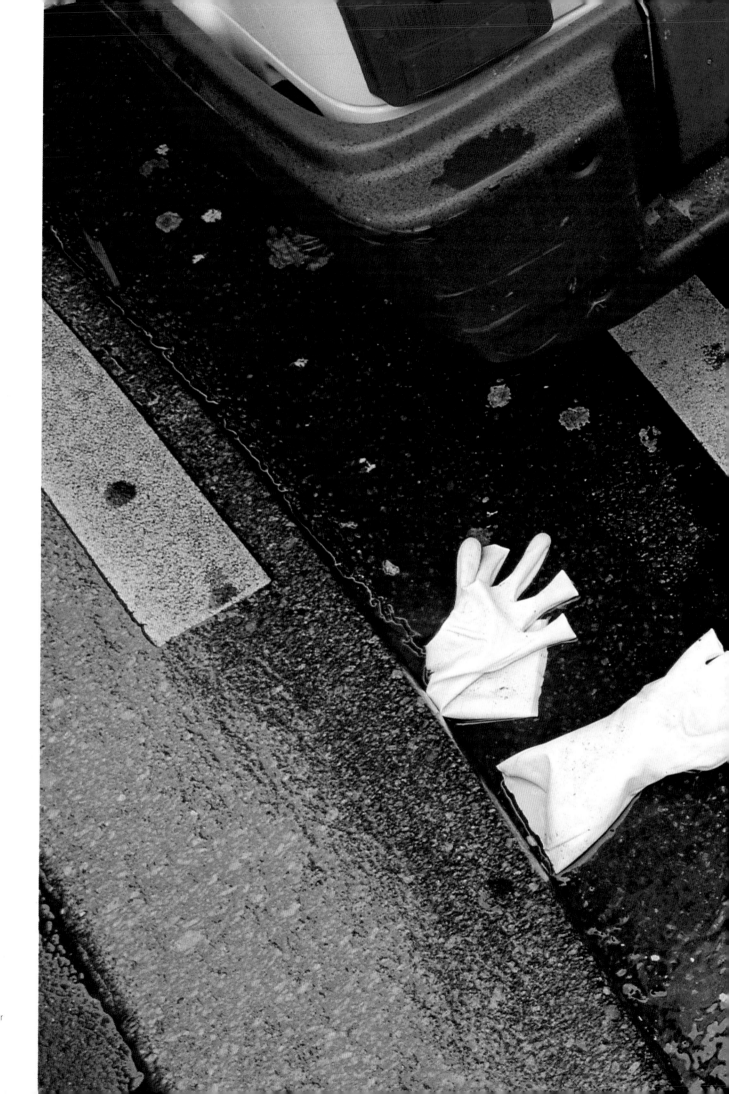

Paris,
October
1996

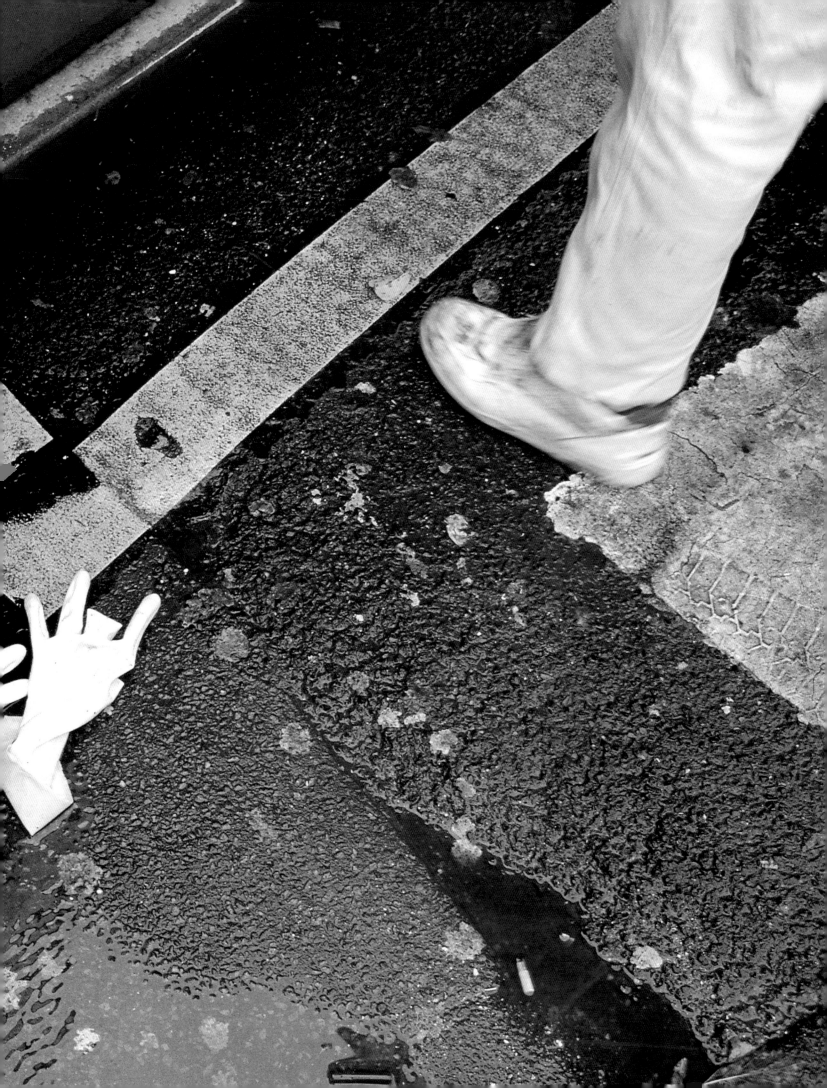

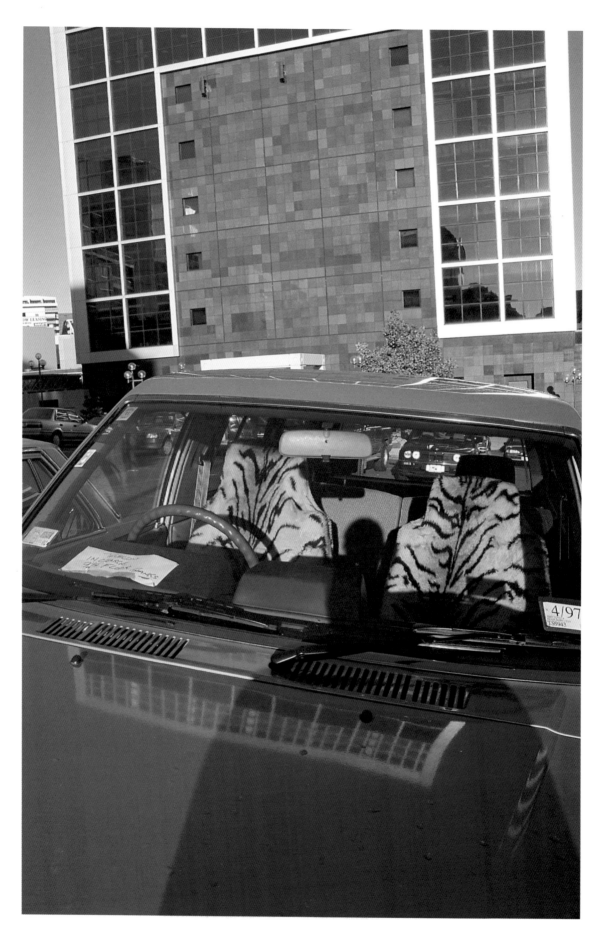

Auckland, May 1996

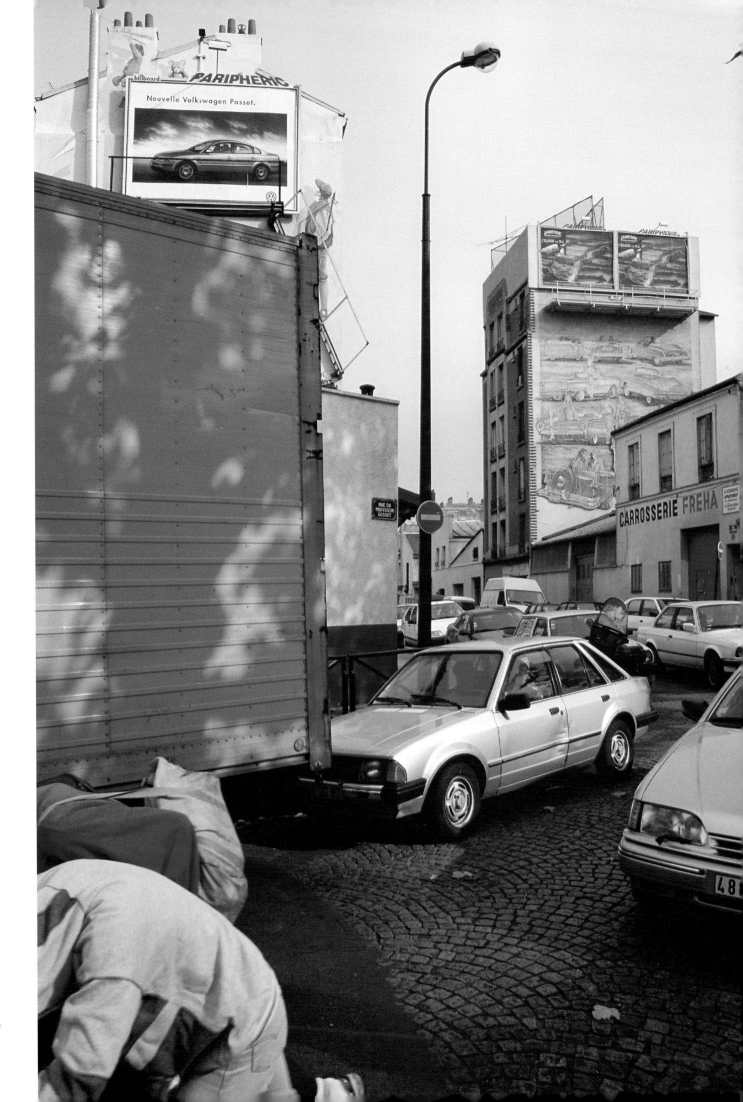

Paris,
October
1996

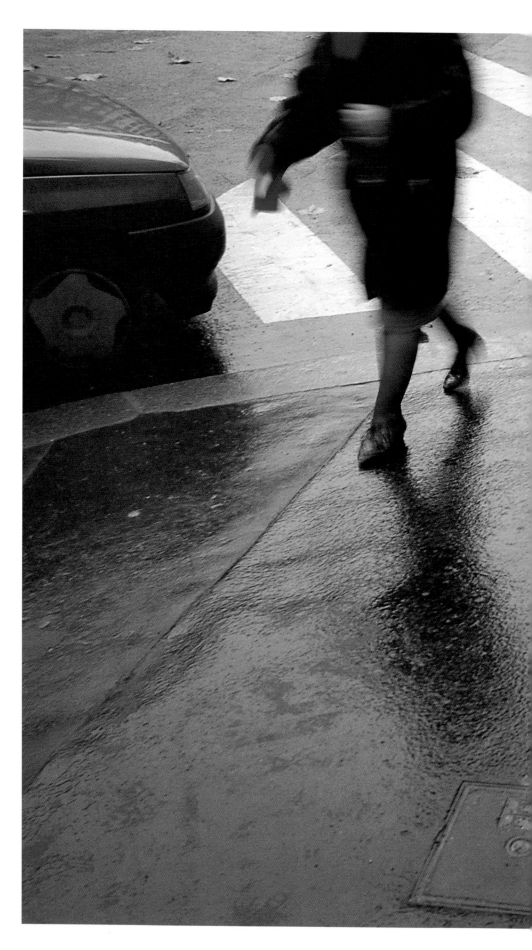

Paris, November 1995

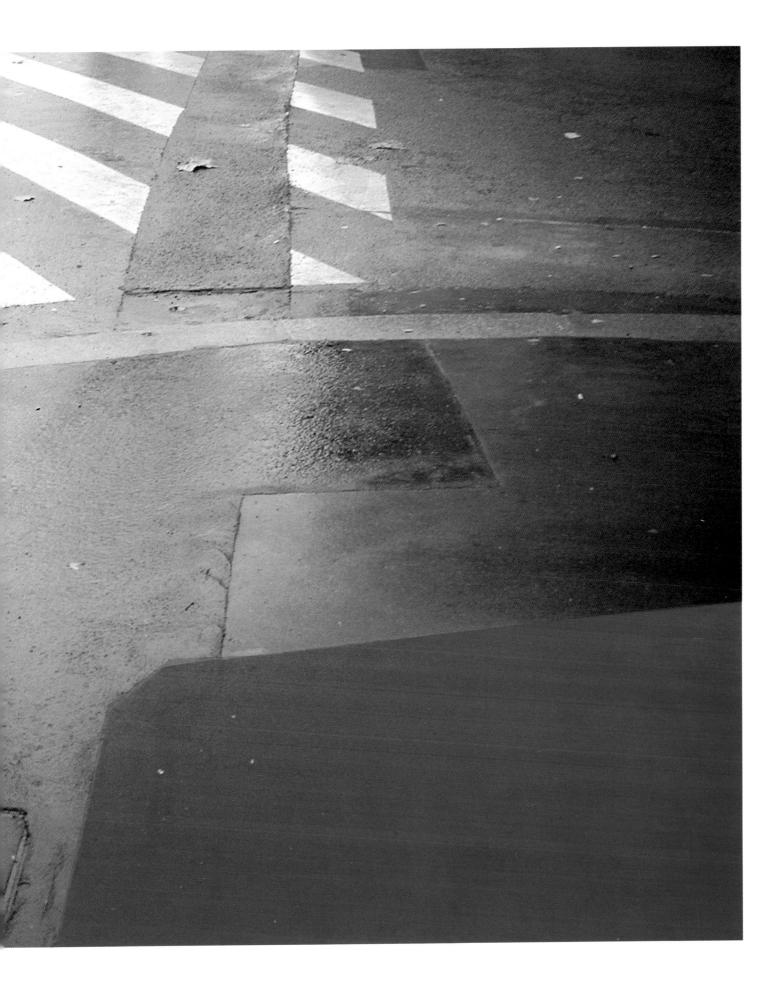

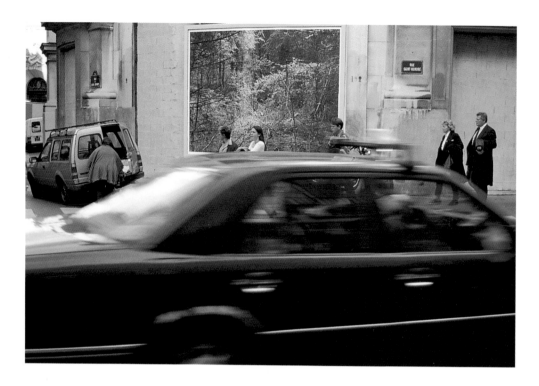

Paris, October 1996

Paris, October 1996

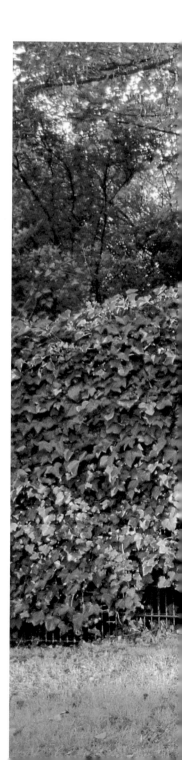

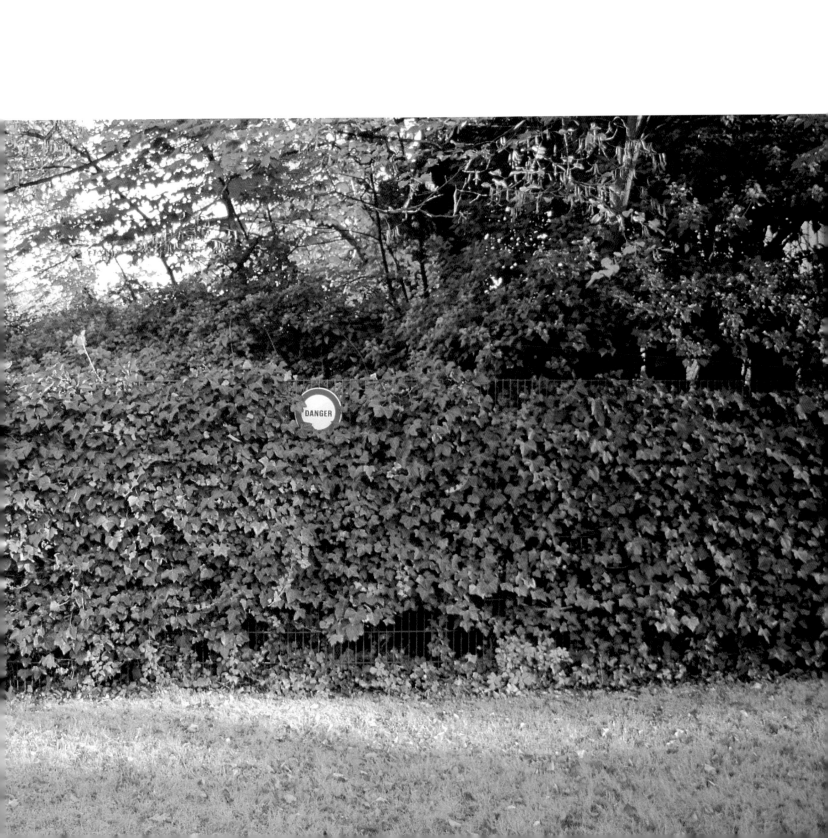

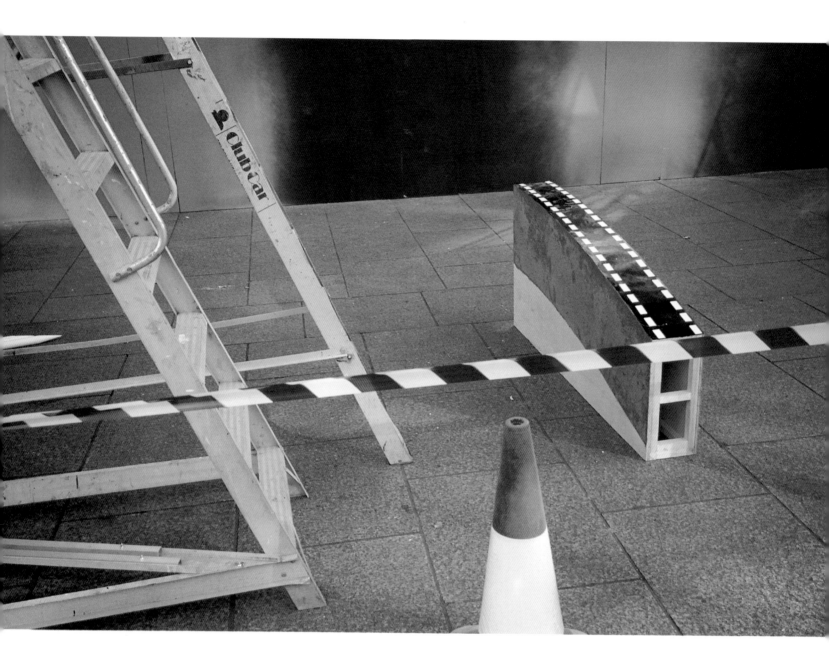

London, November 1996

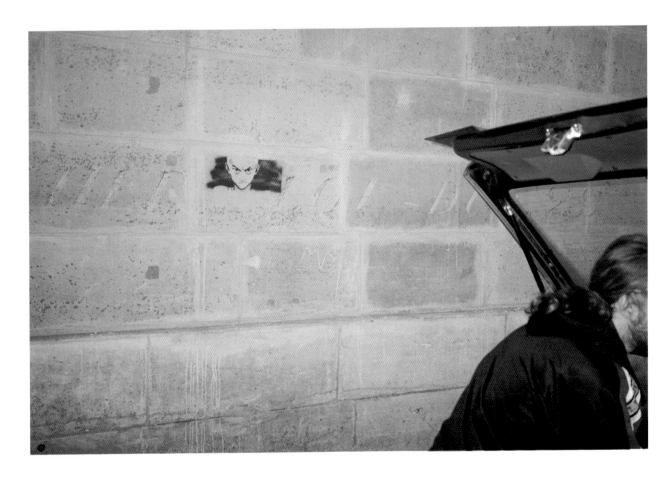

Paris, October 1996

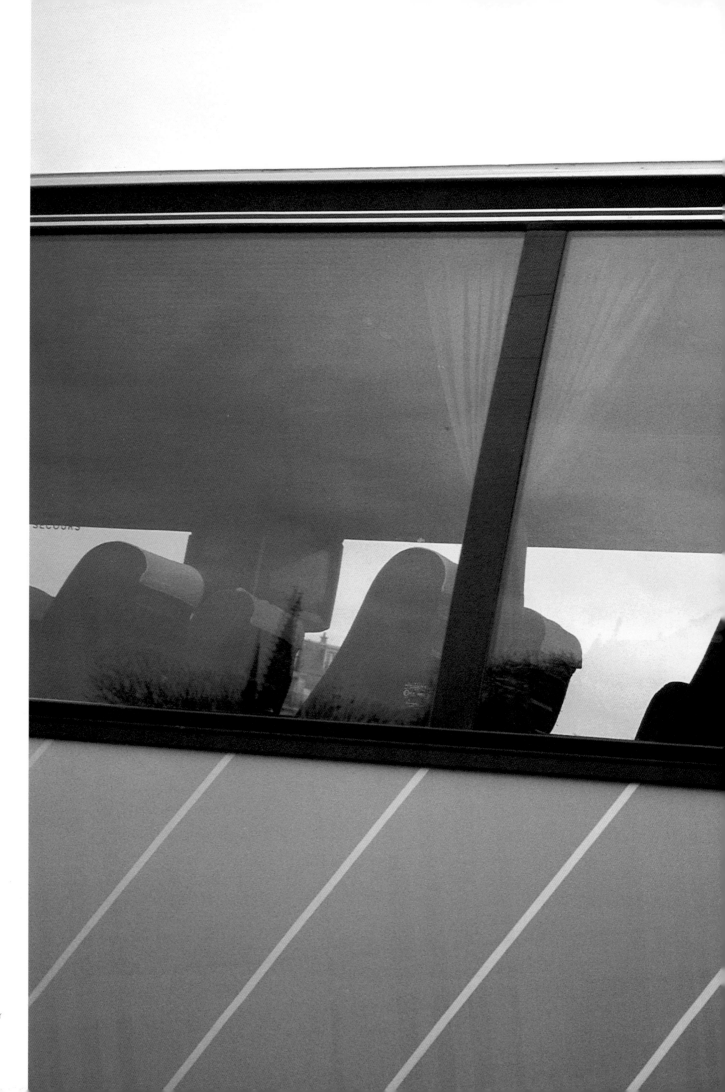

Paris,
December
1994

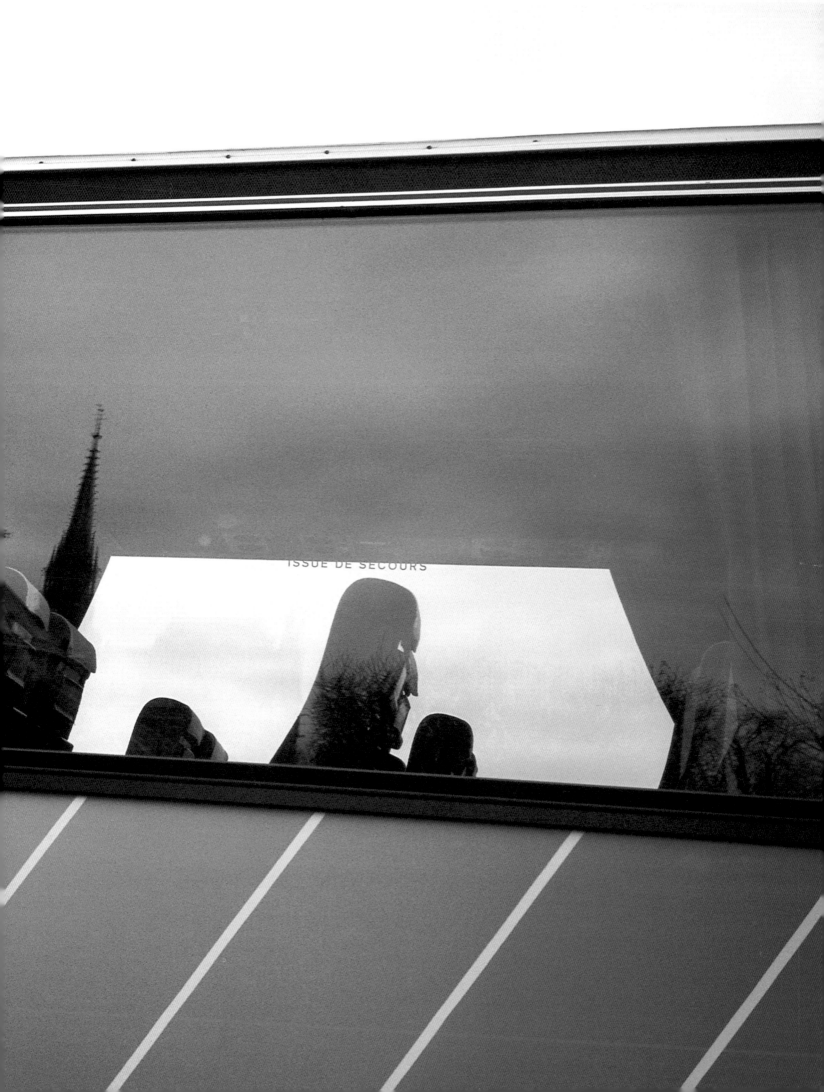

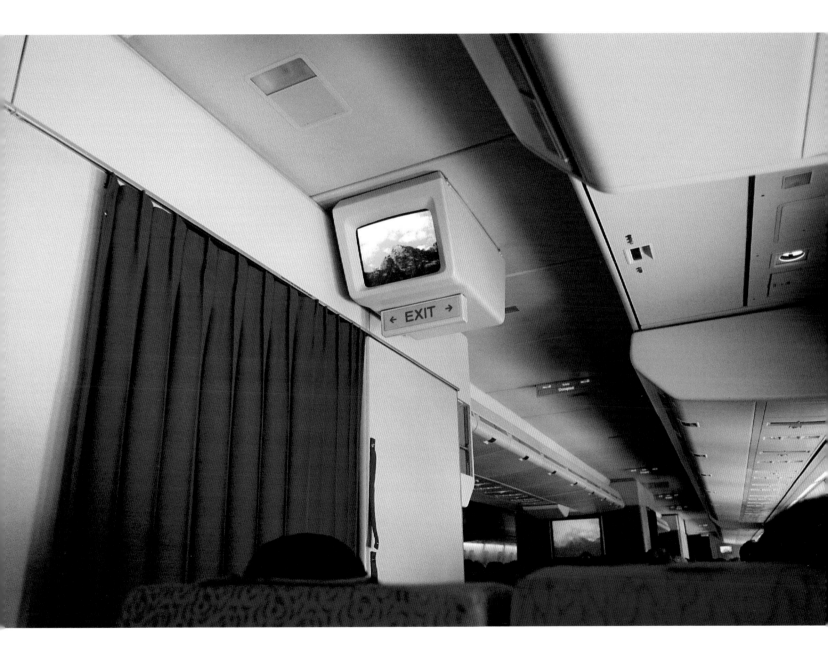

Over Tasman Sea, August 1996

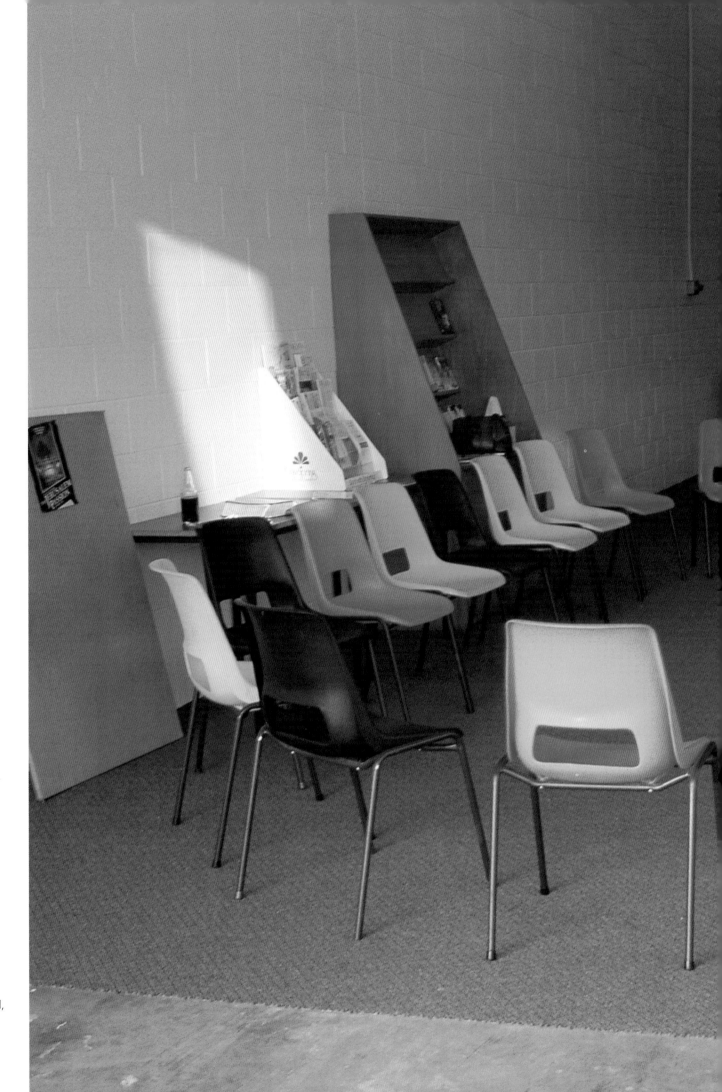

Auckland,
1994

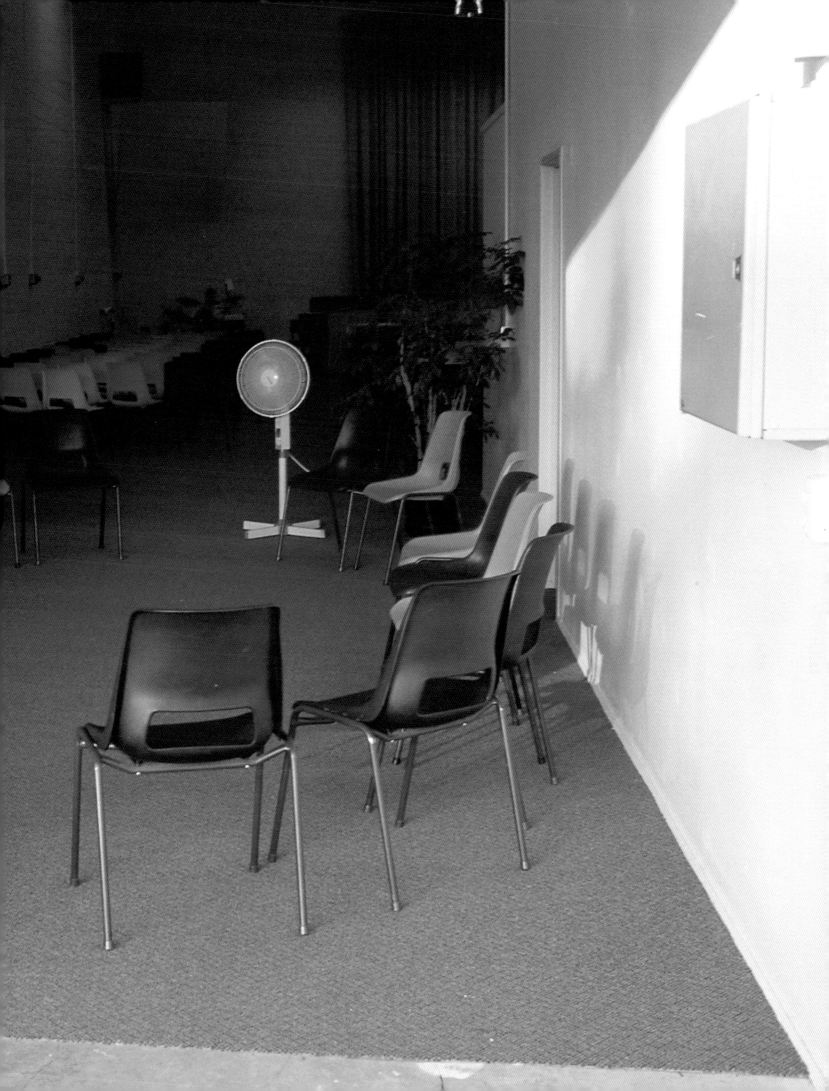

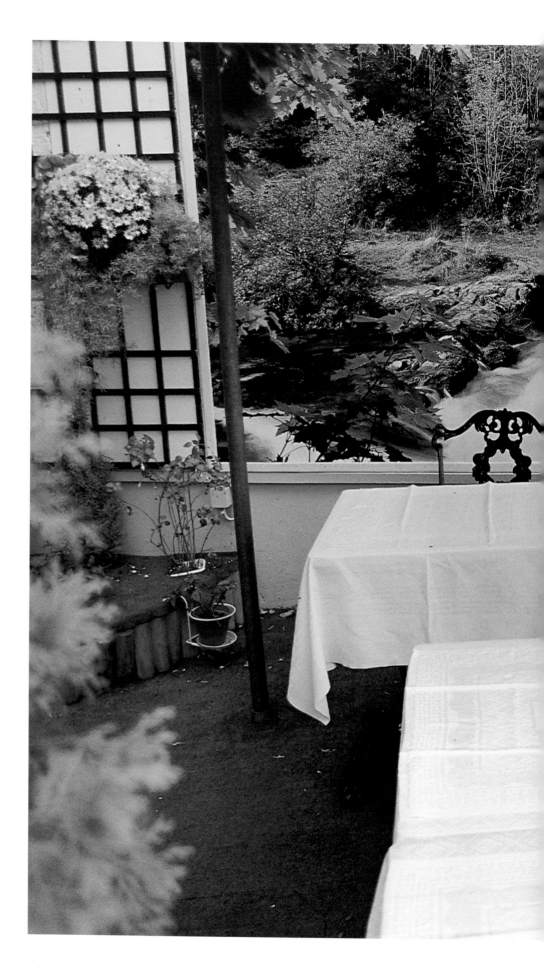

Paris, October 1996

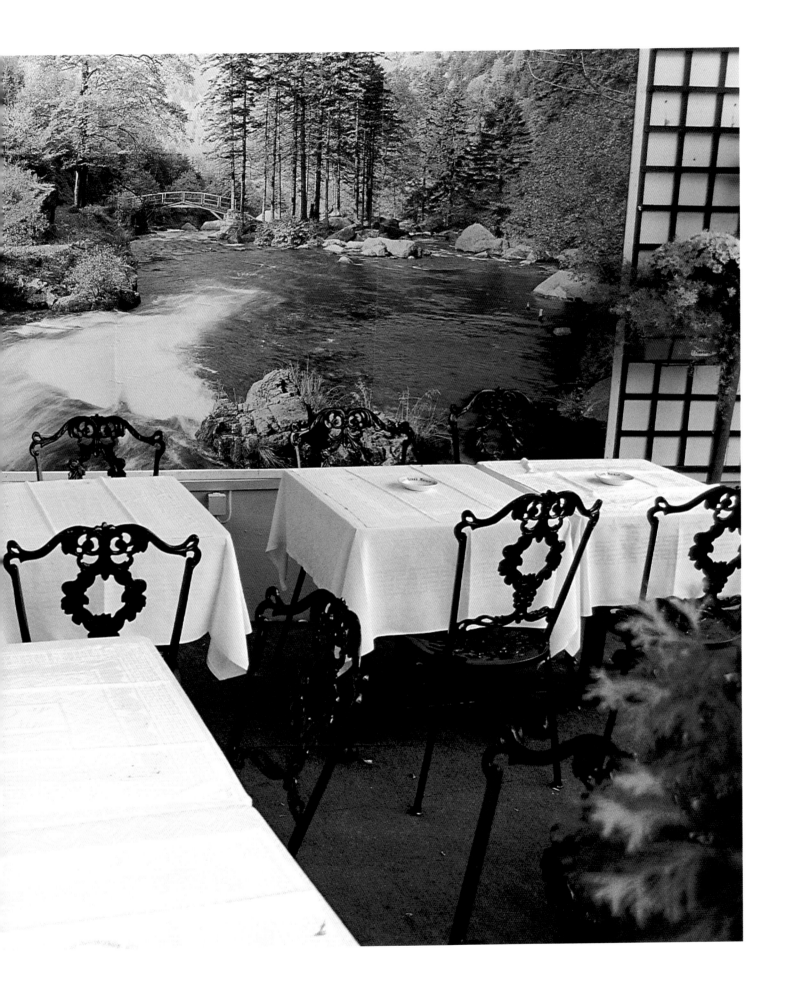

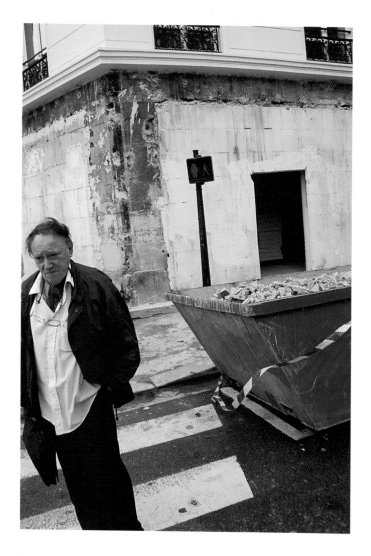

Paris, October 1996

Paris, October 1996

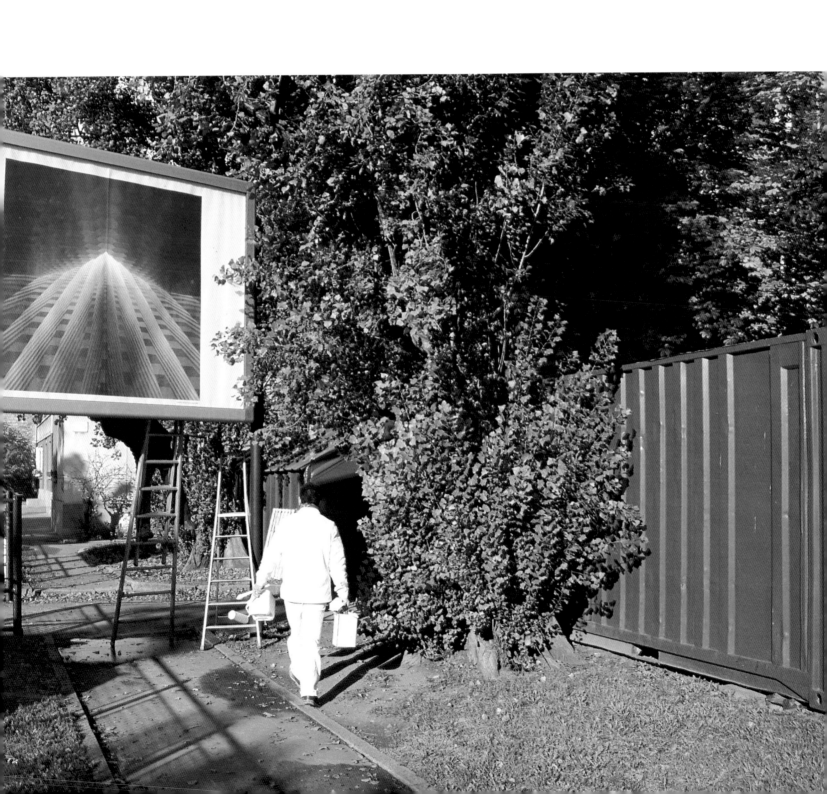

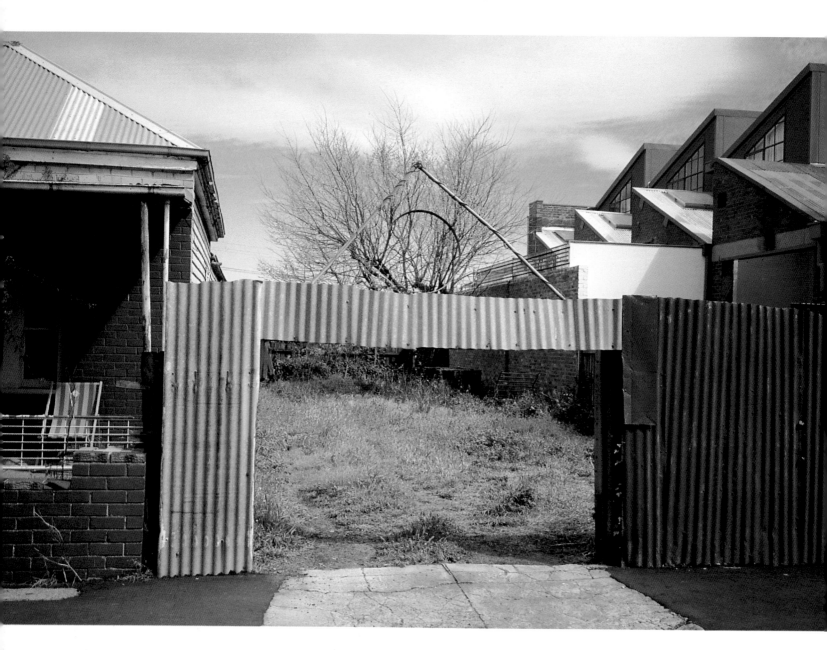

Melbourne, October 1994

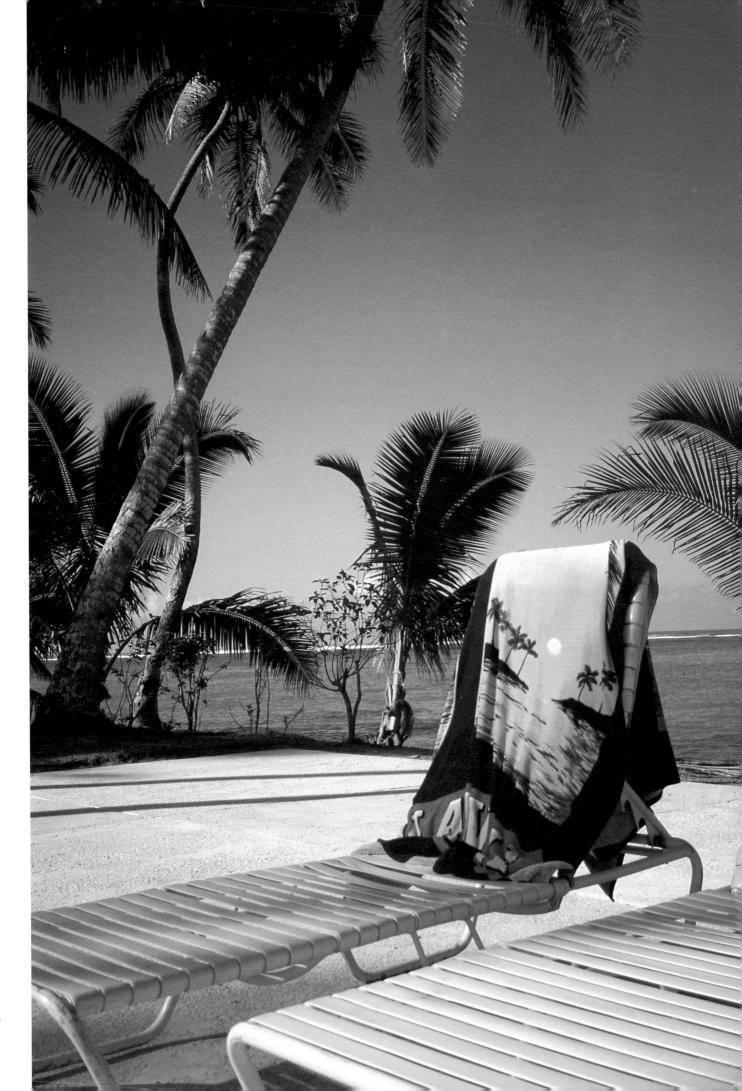

Fiji,
July 1996

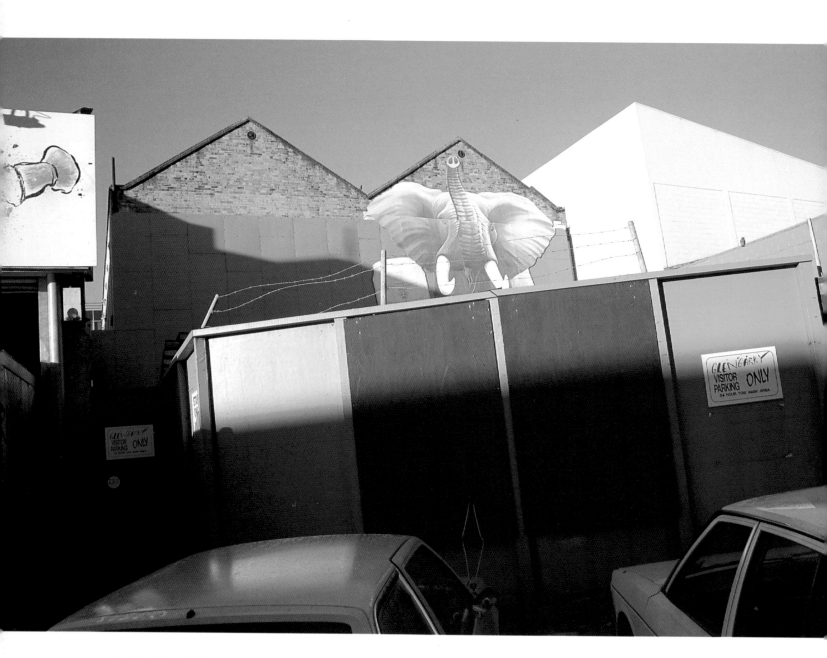

Auckland, May 1996

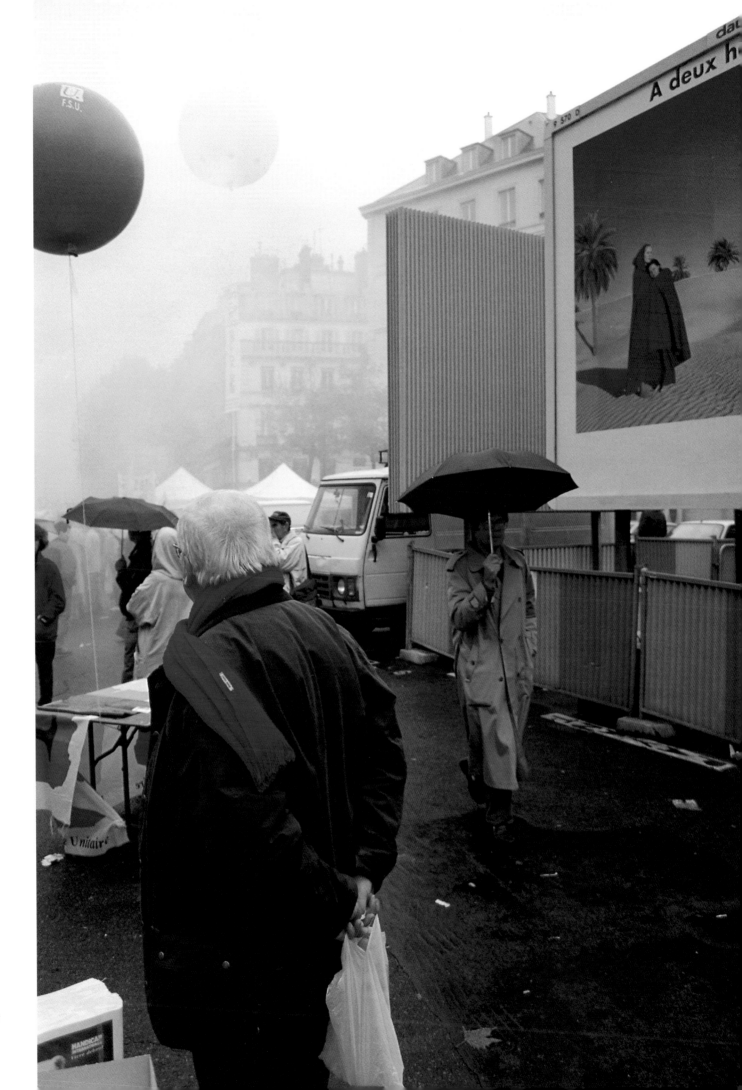

Paris,
October
1996

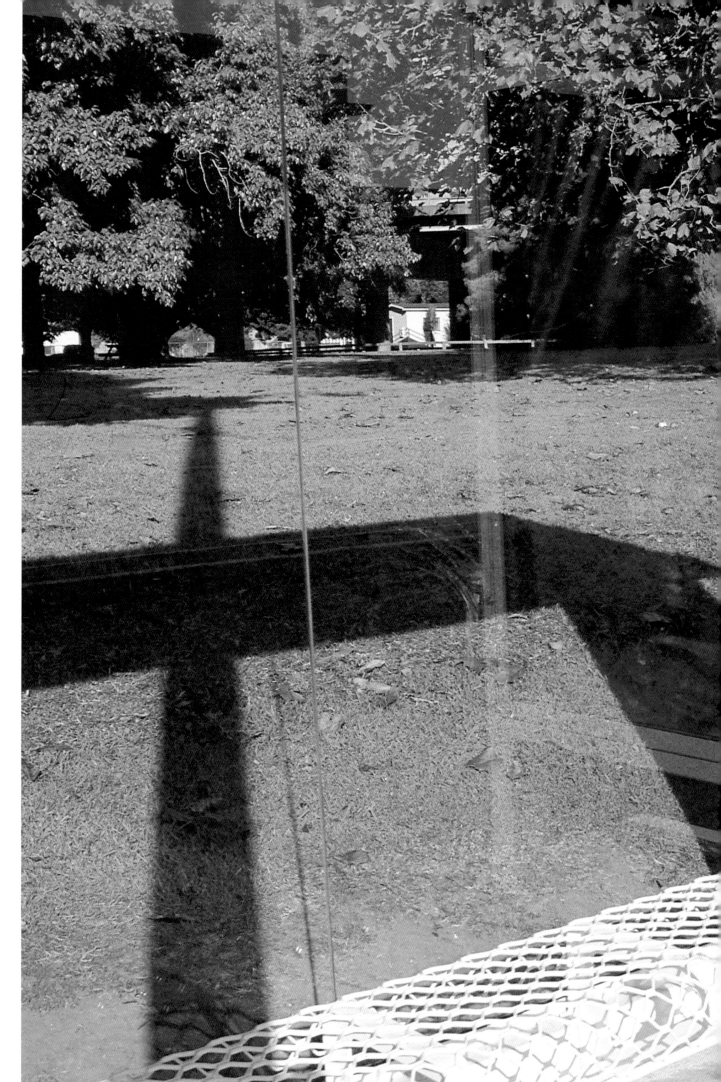

Auckland,
May 1994

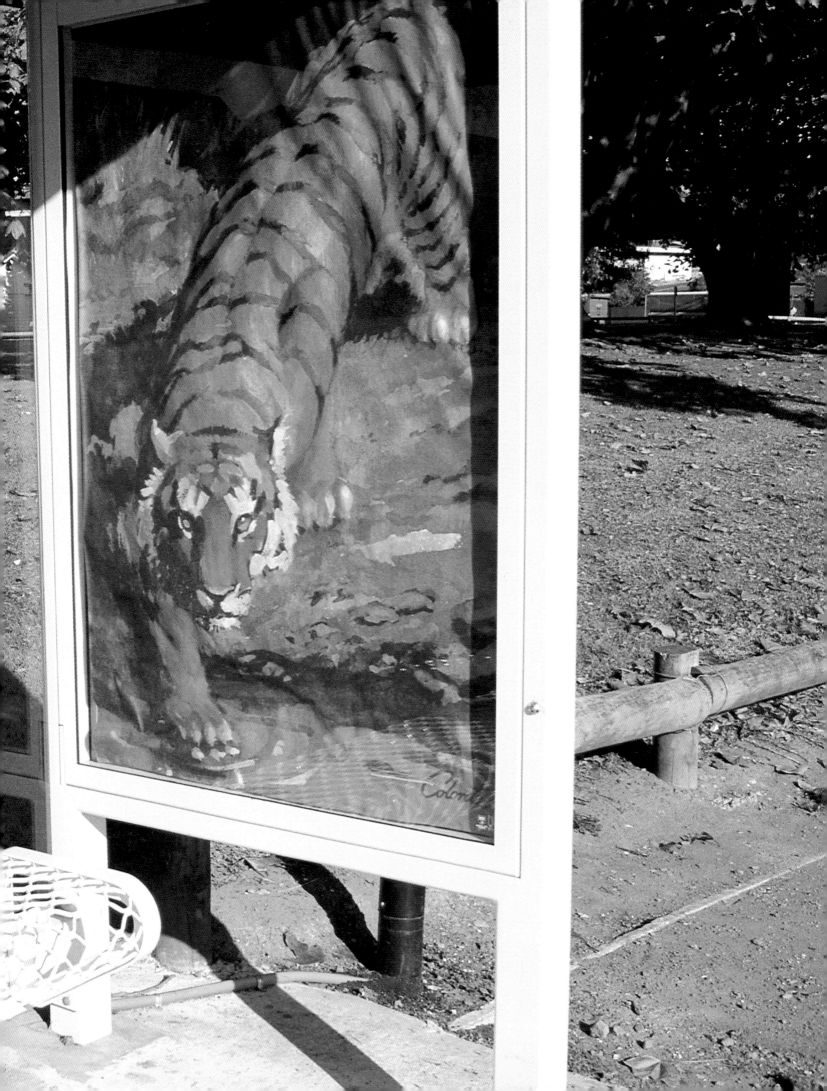

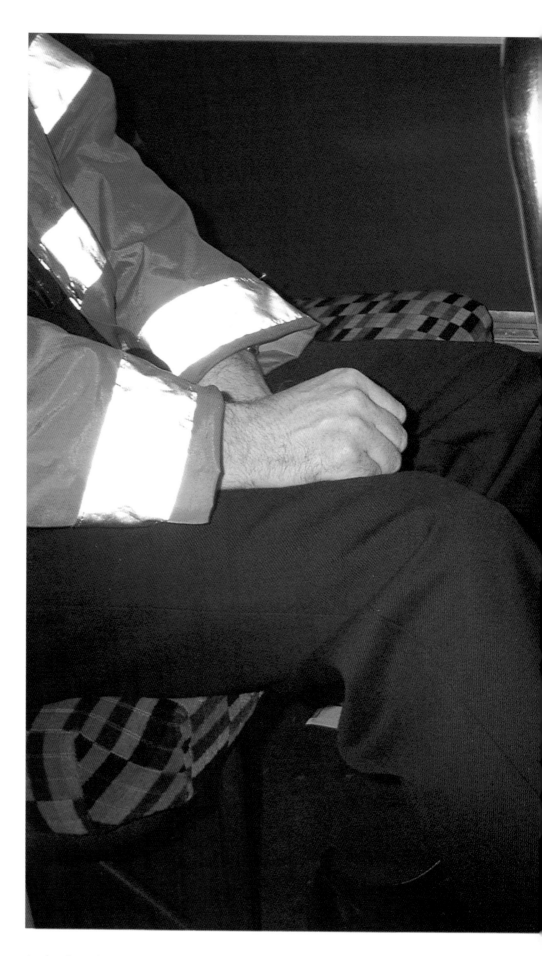

London, December 1994

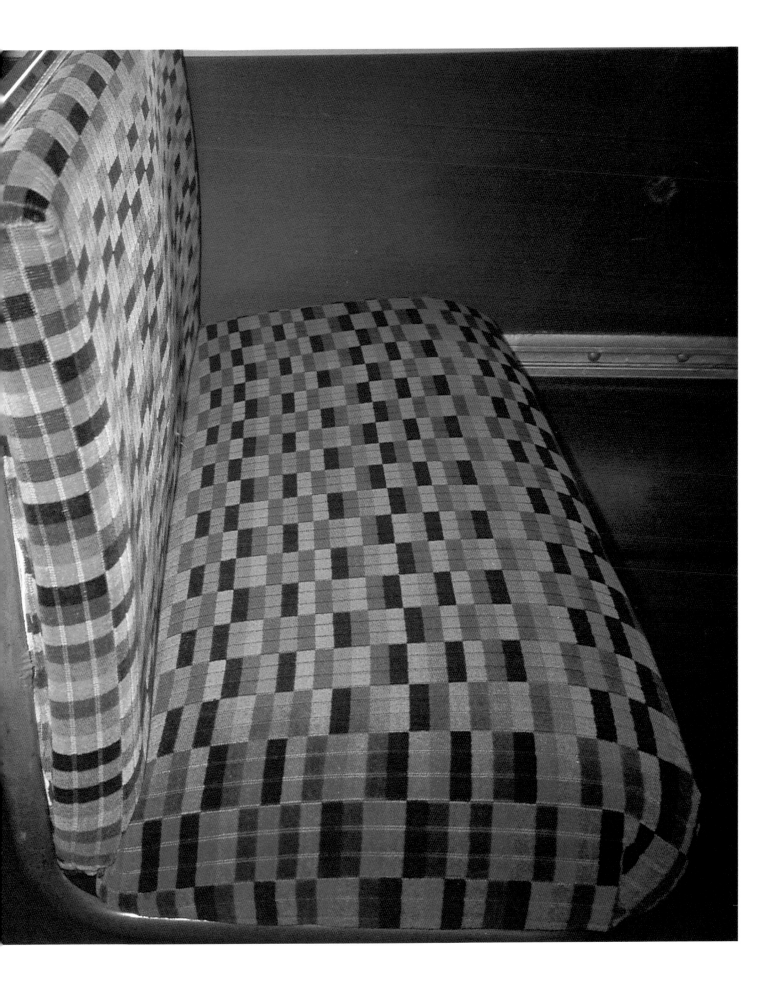

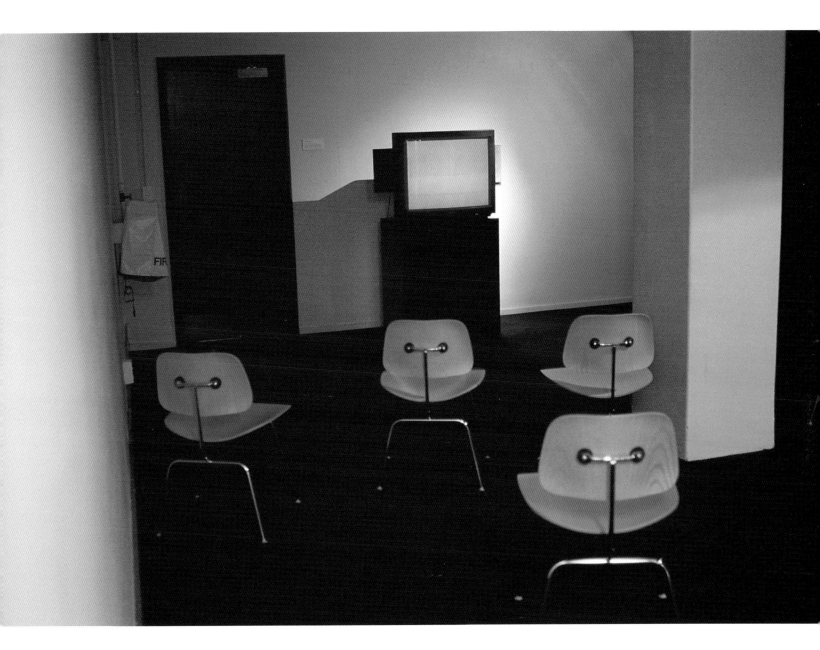

Wellington, March 1994

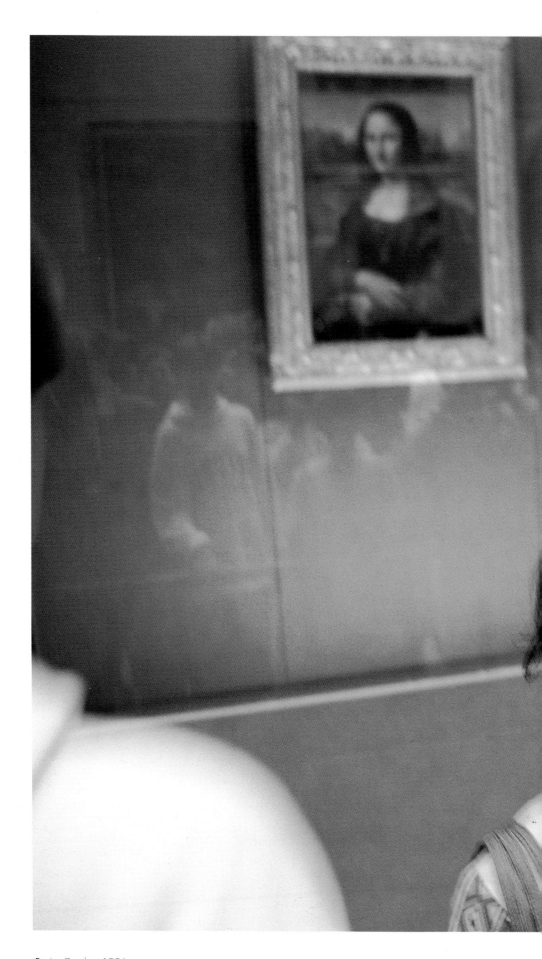

Paris, October 1996

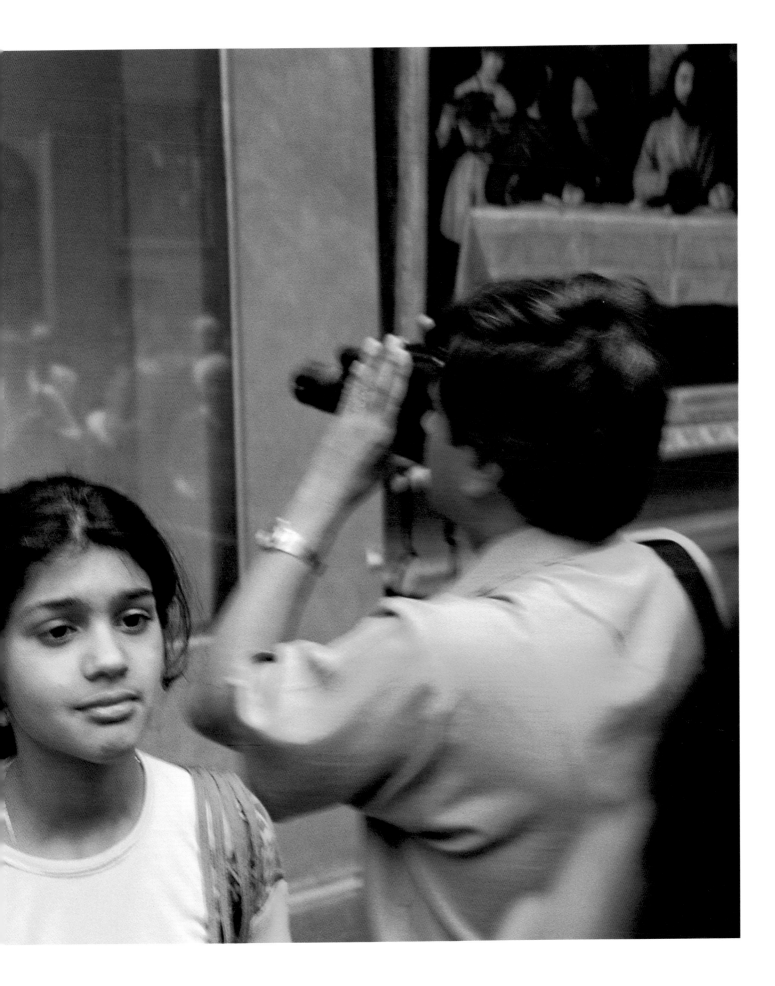

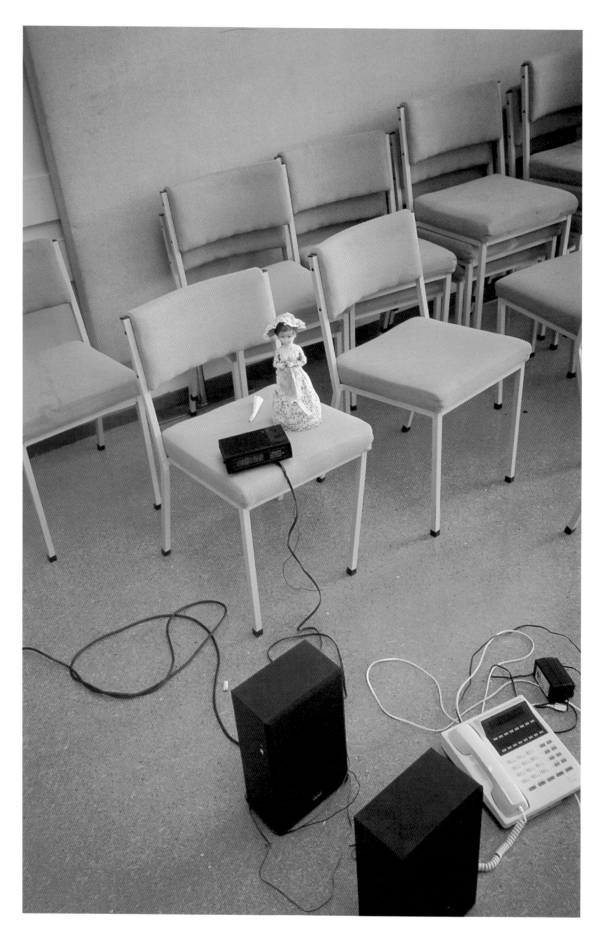

Auckland, July 1995

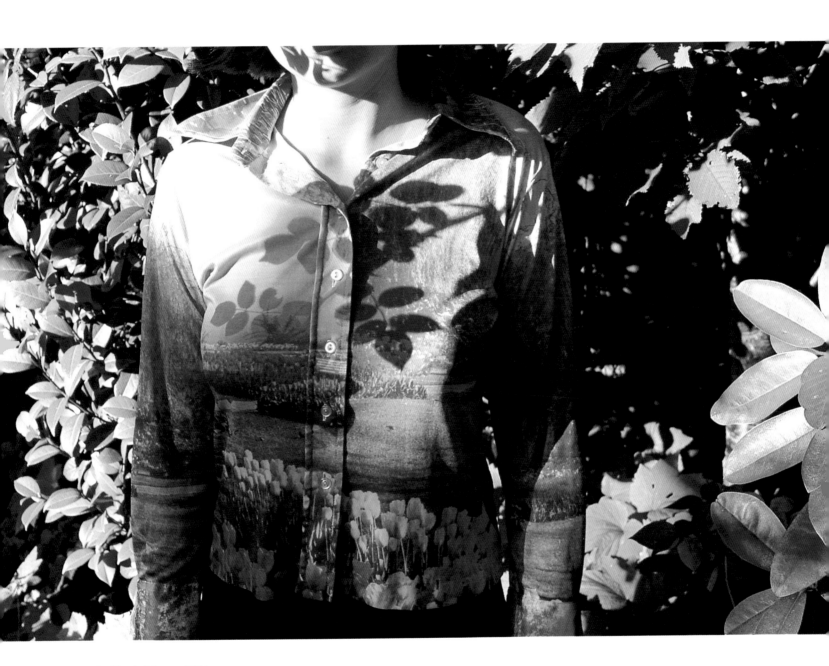

Auckland, February 1996

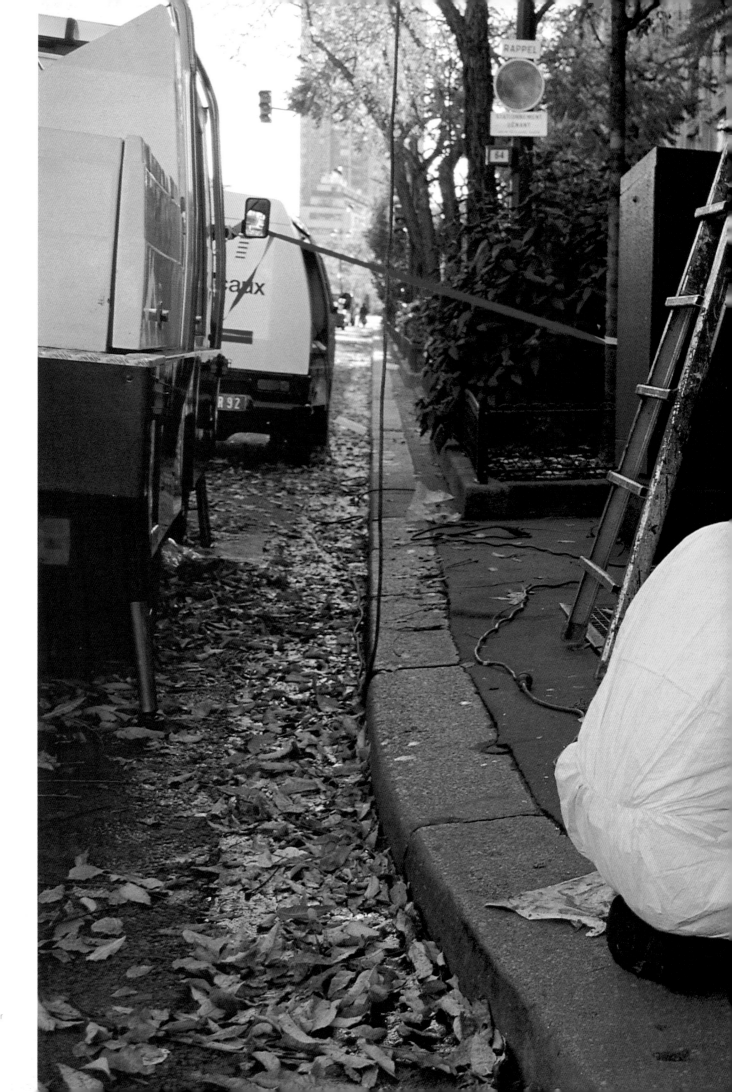

Paris,
October
1996

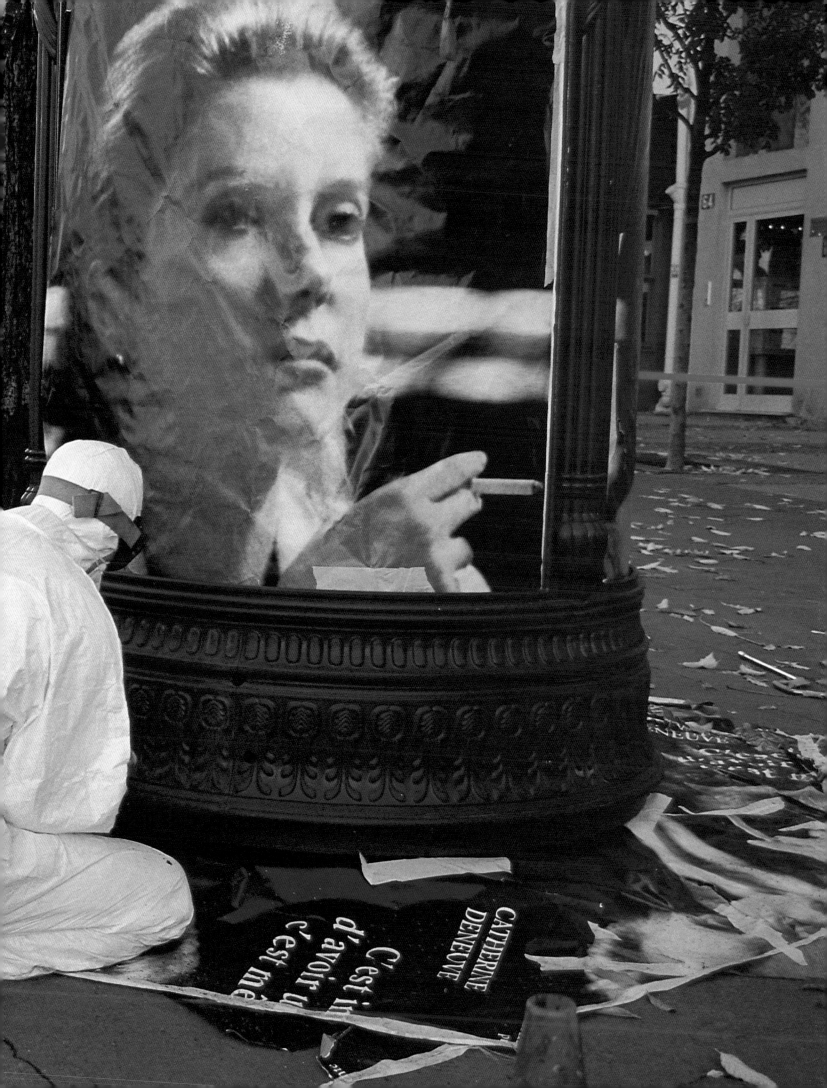

CATHERINE DENEUVE

C'est in
d'avoir u
c'est me

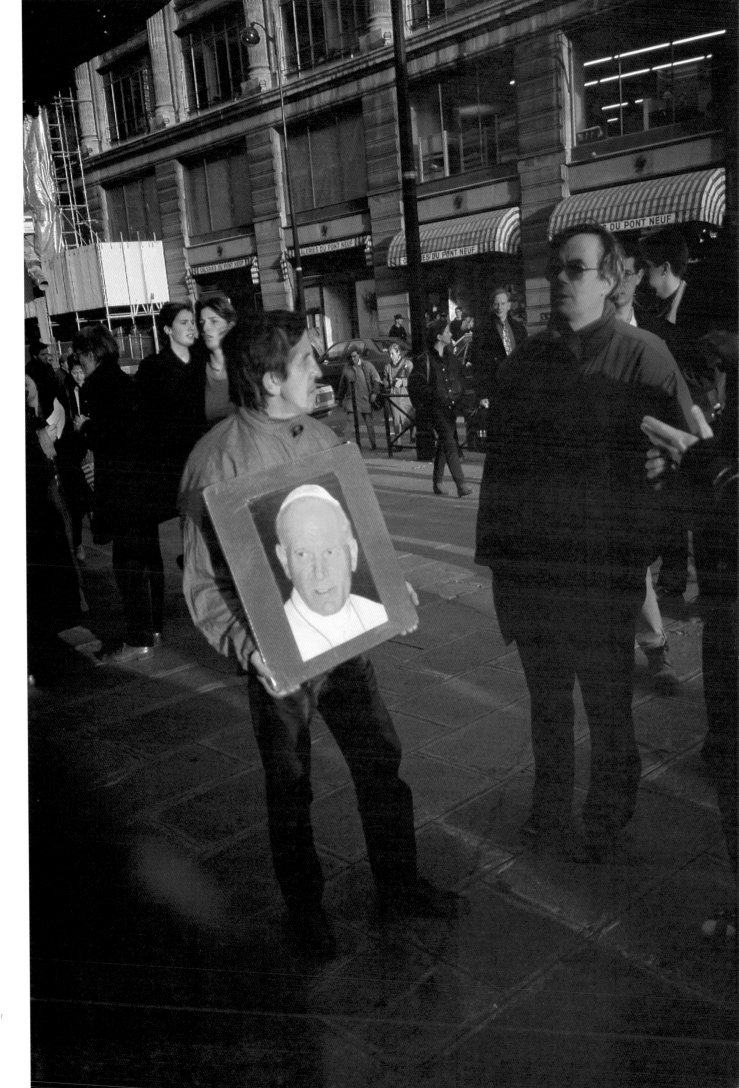

Paris,
November
1995

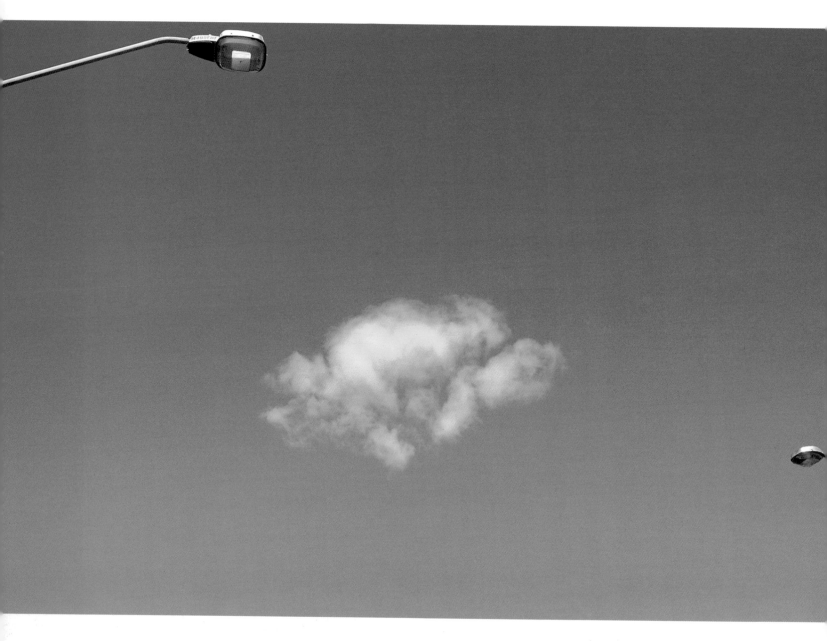

Sydney, October 1995

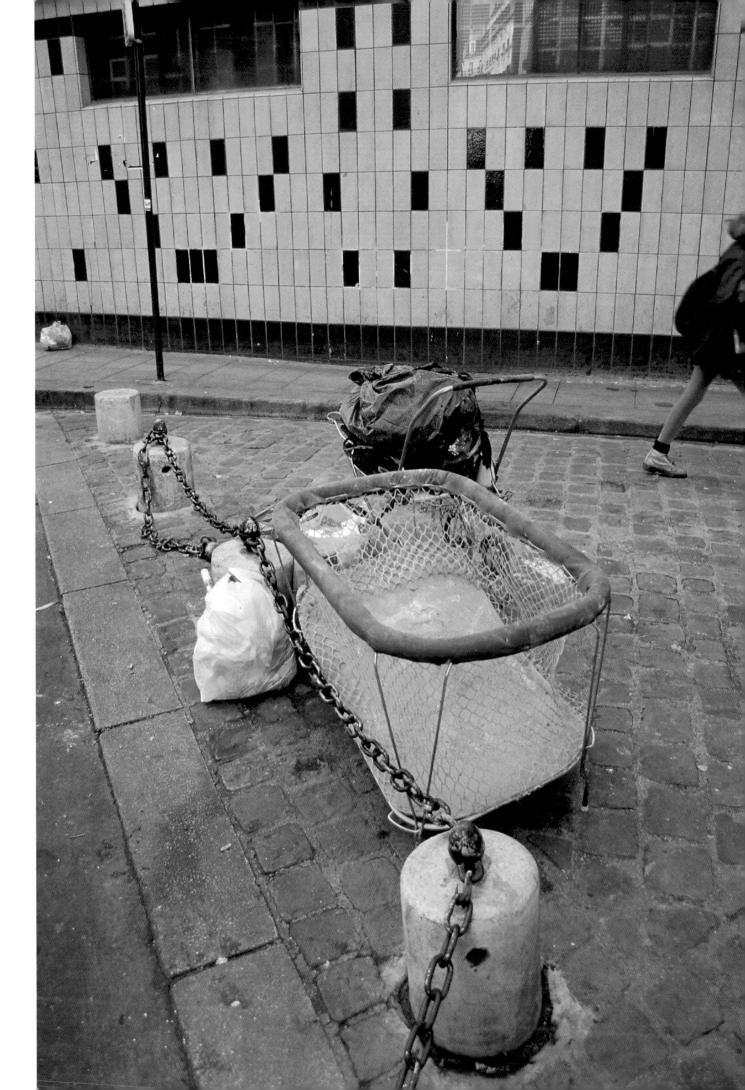

Paris,
October
1996

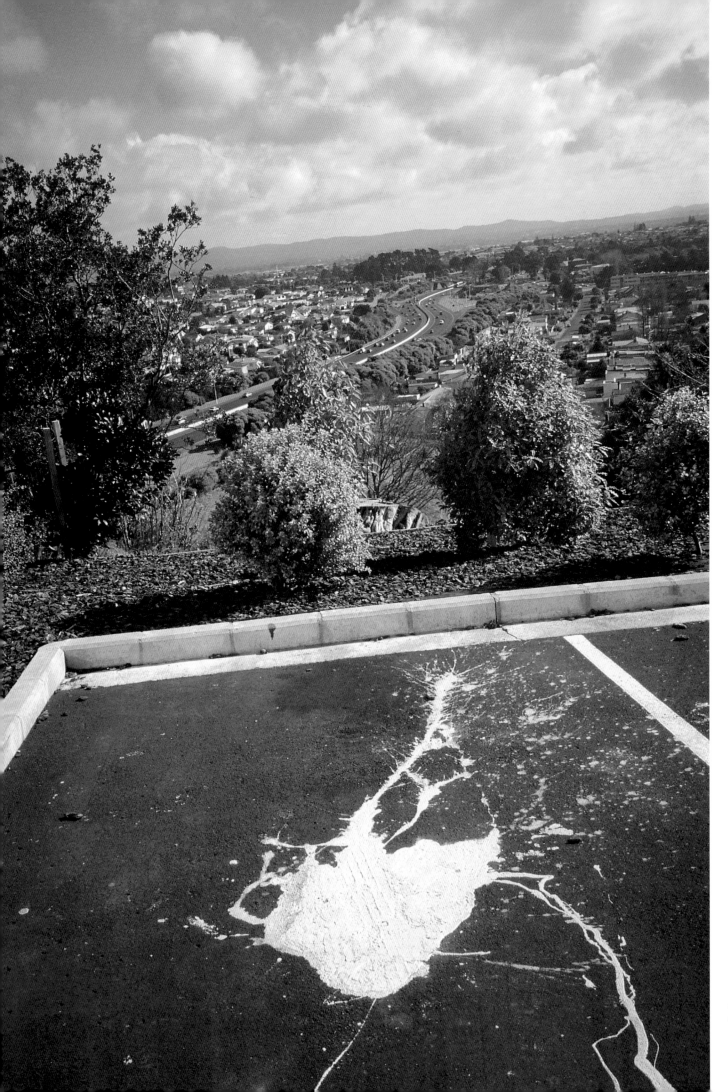

Auckland,
April 1995

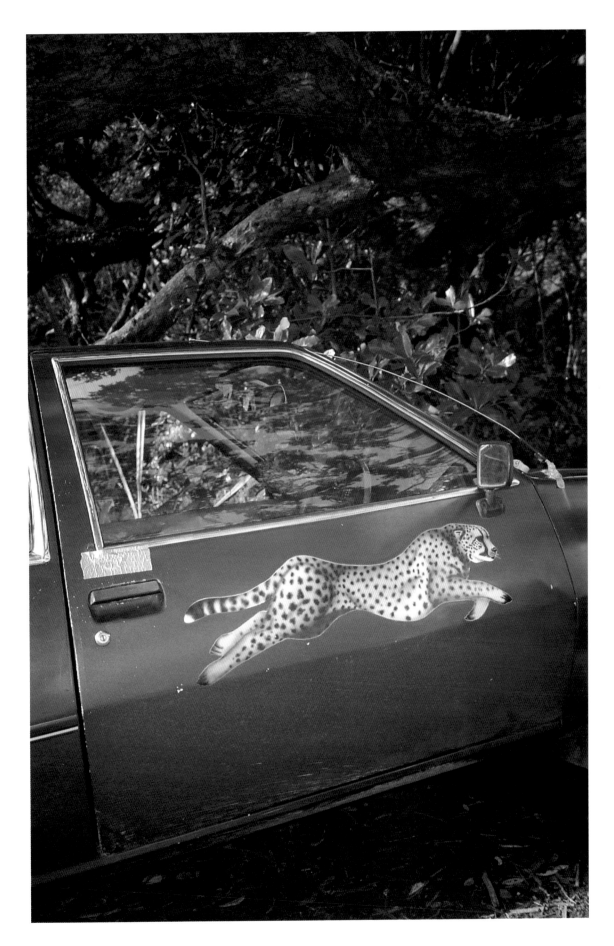

Auckland, September 1995

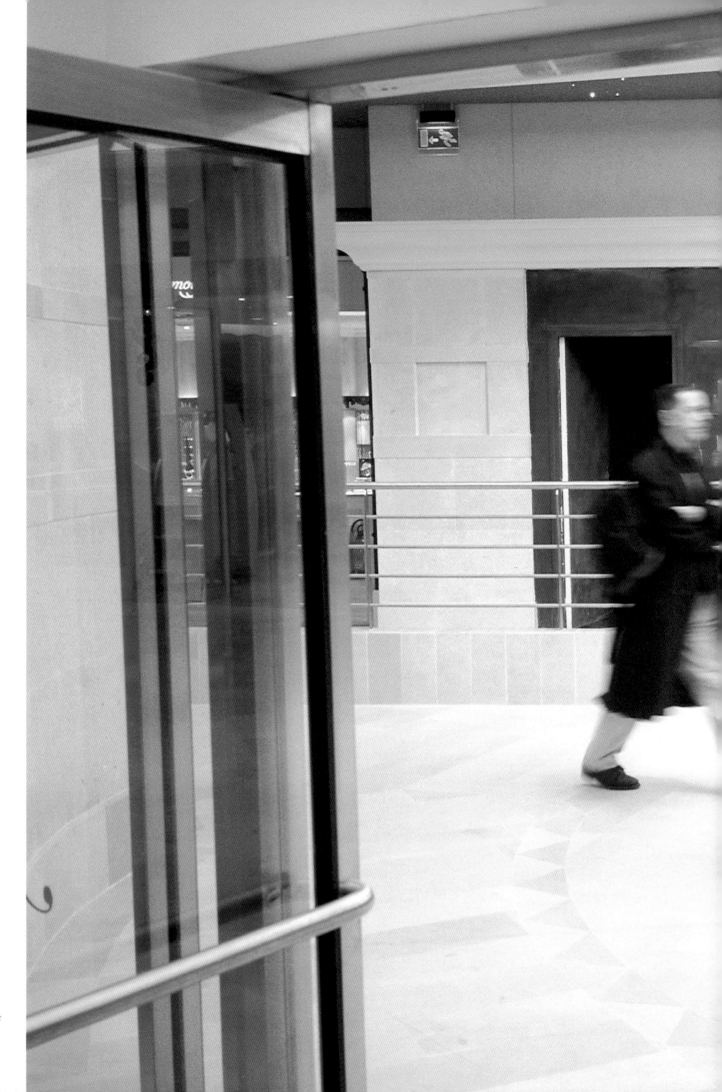

Paris,
November
1995

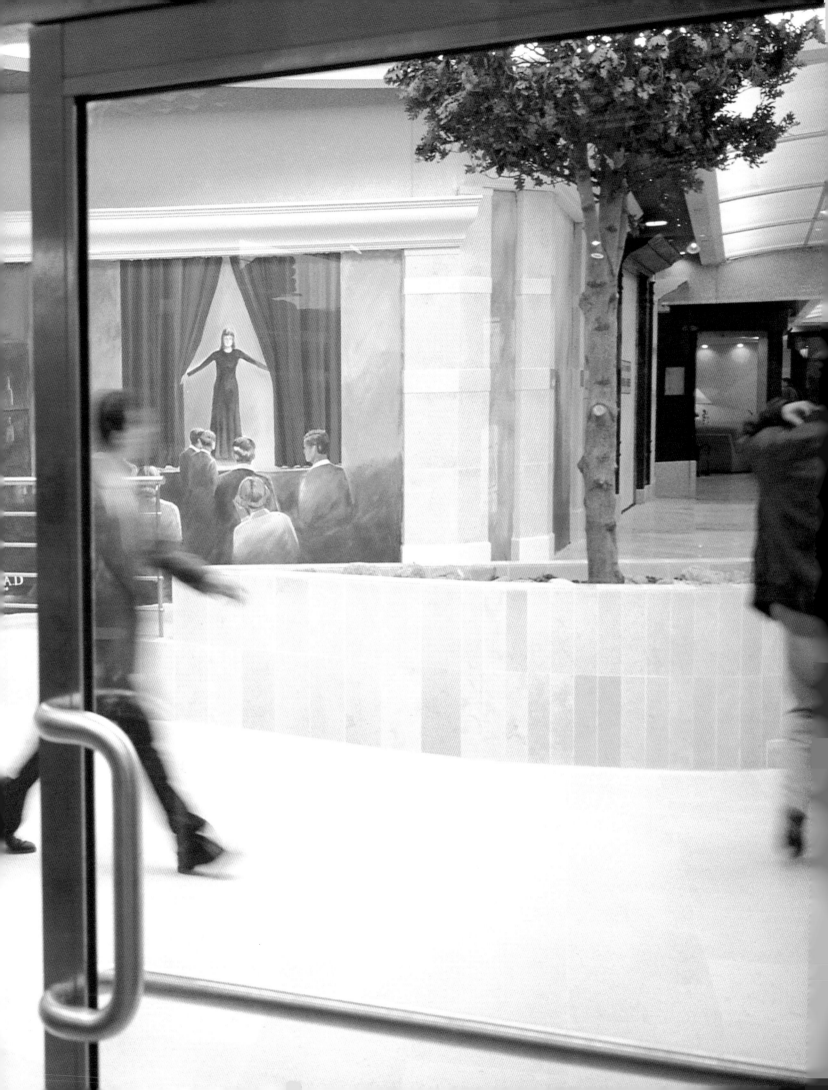

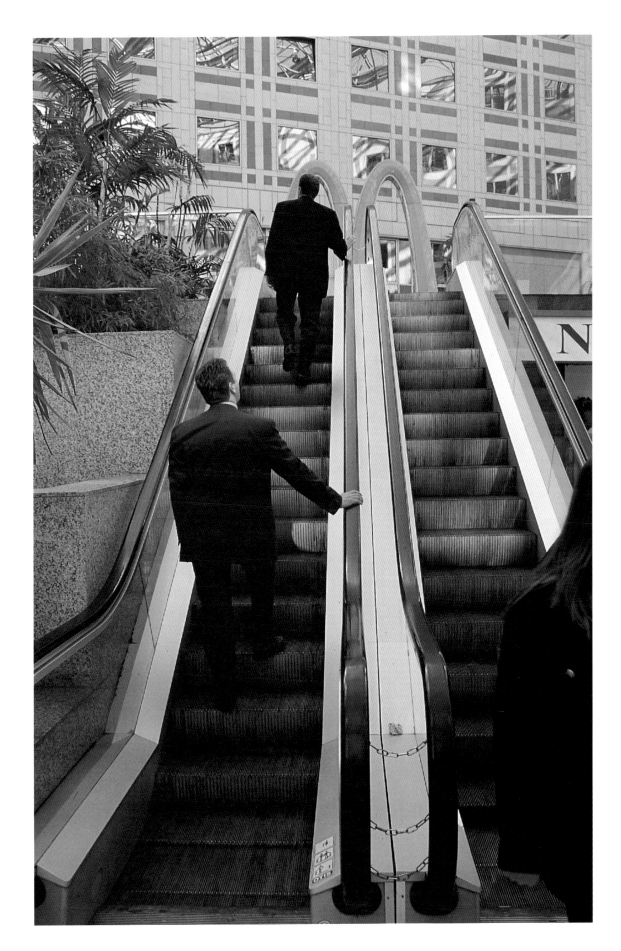

Paris, October 1996

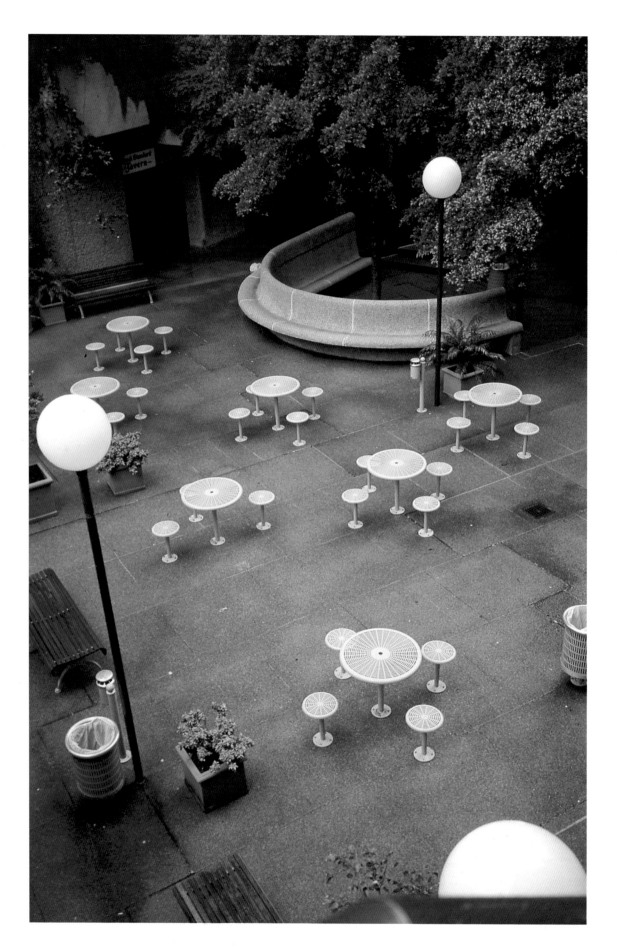

Sydney, October 1995

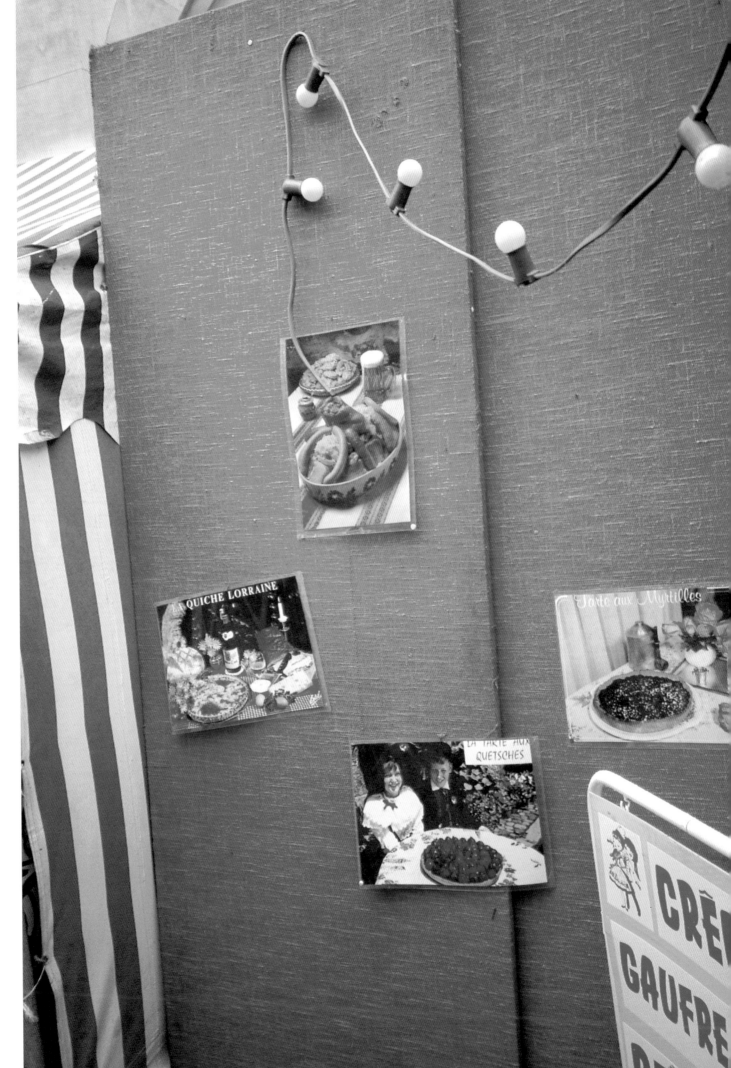

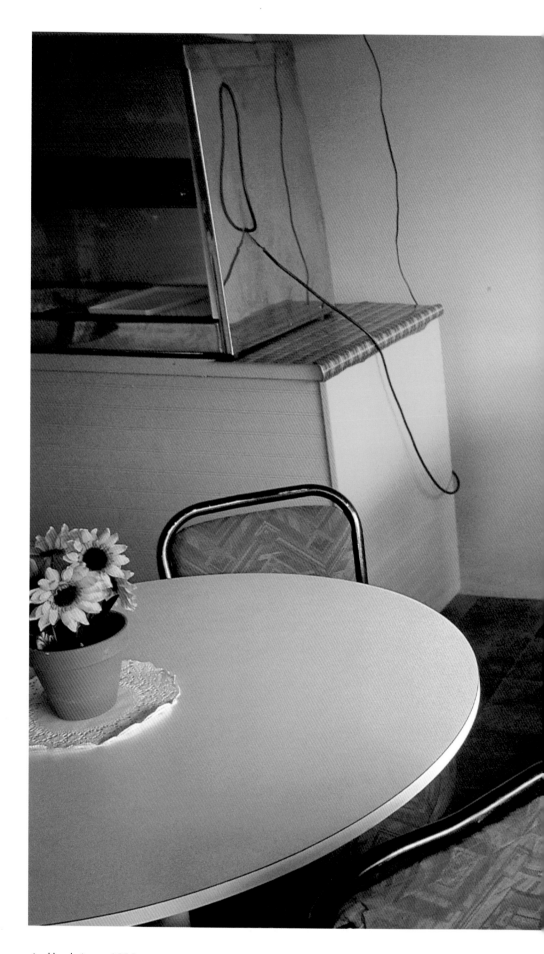

Auckland, August 1995

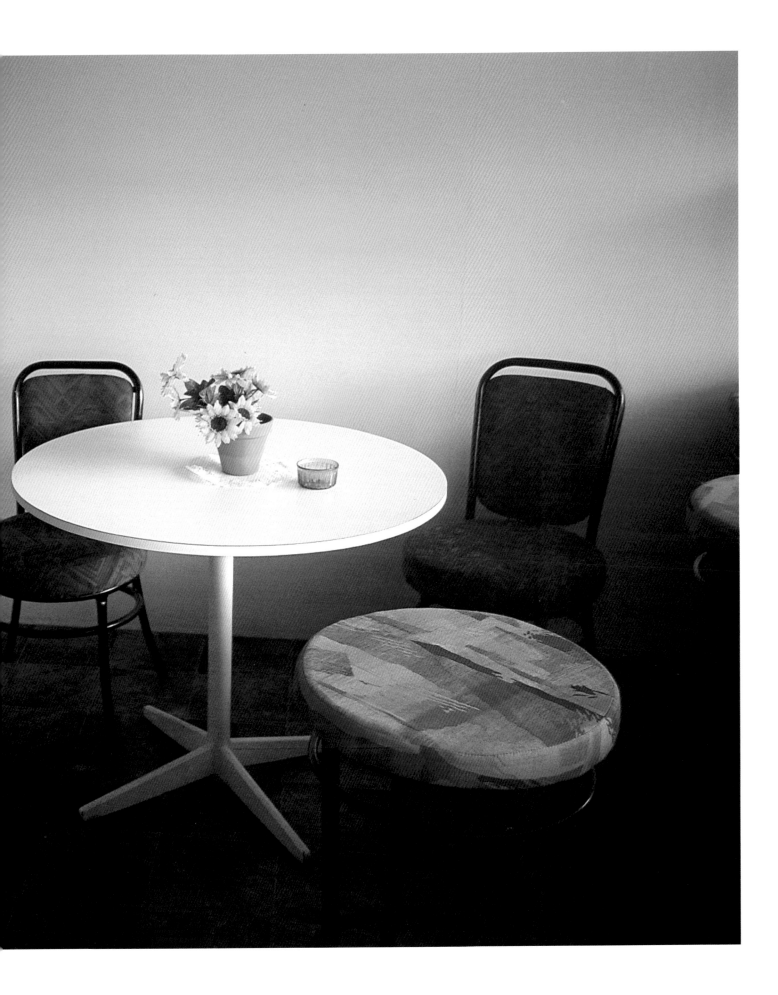

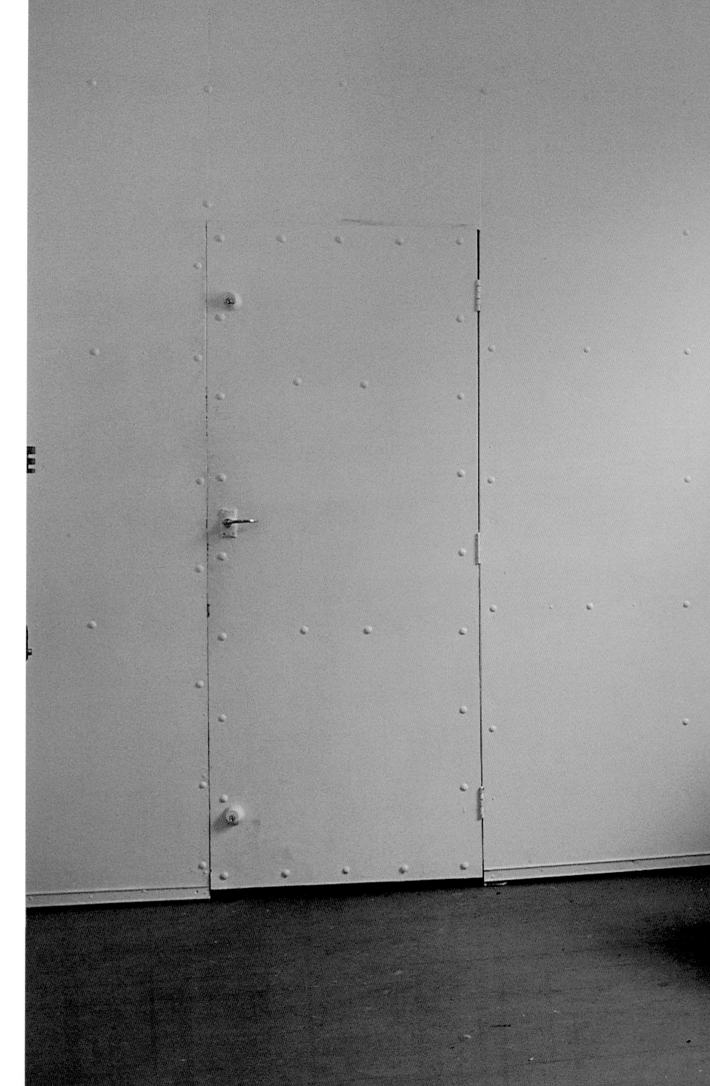

Auckland,
August
1996

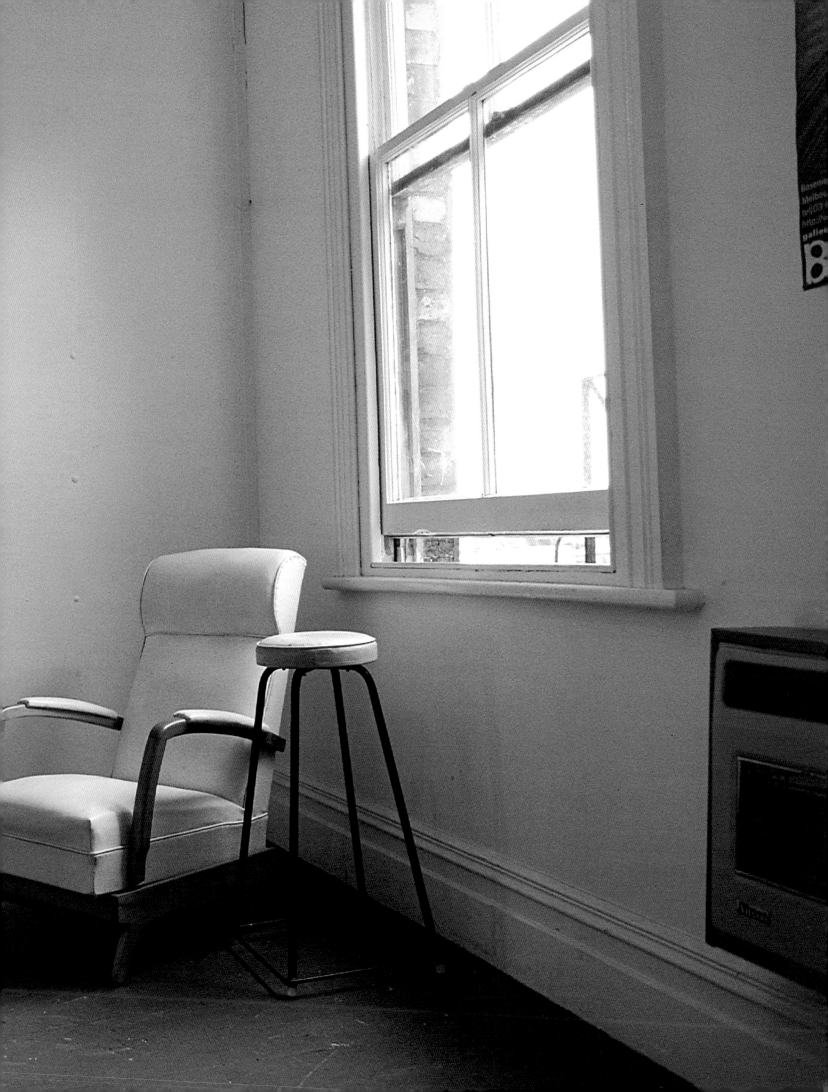

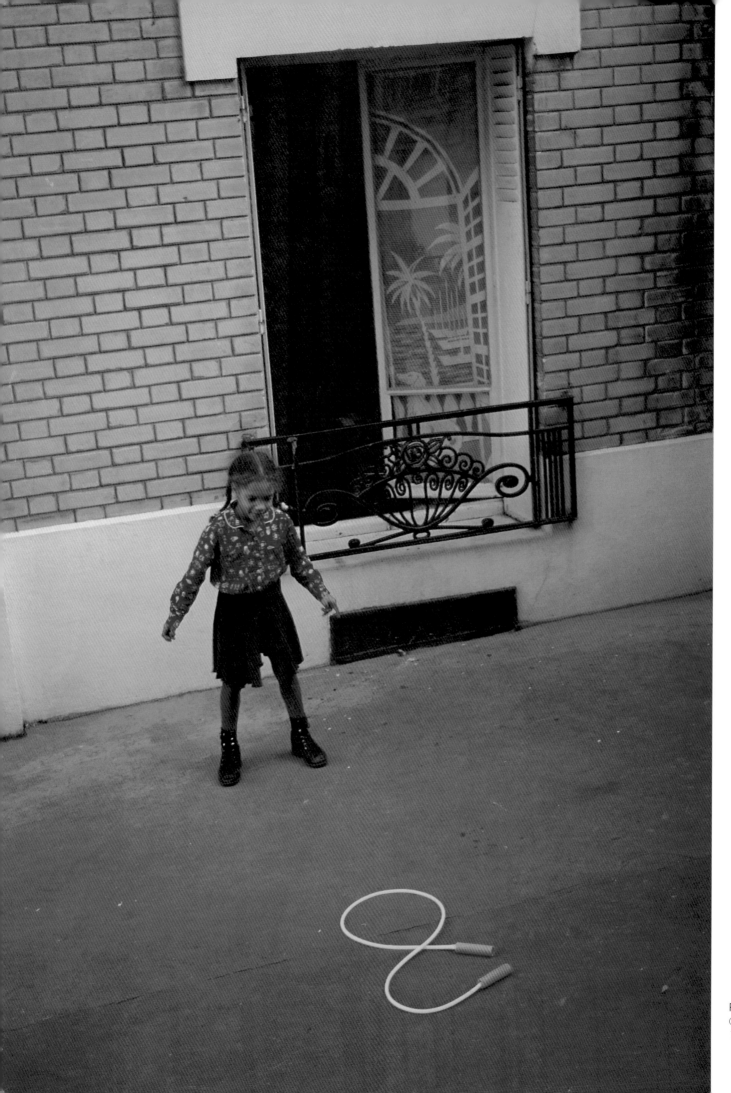

Paris,
October
1996

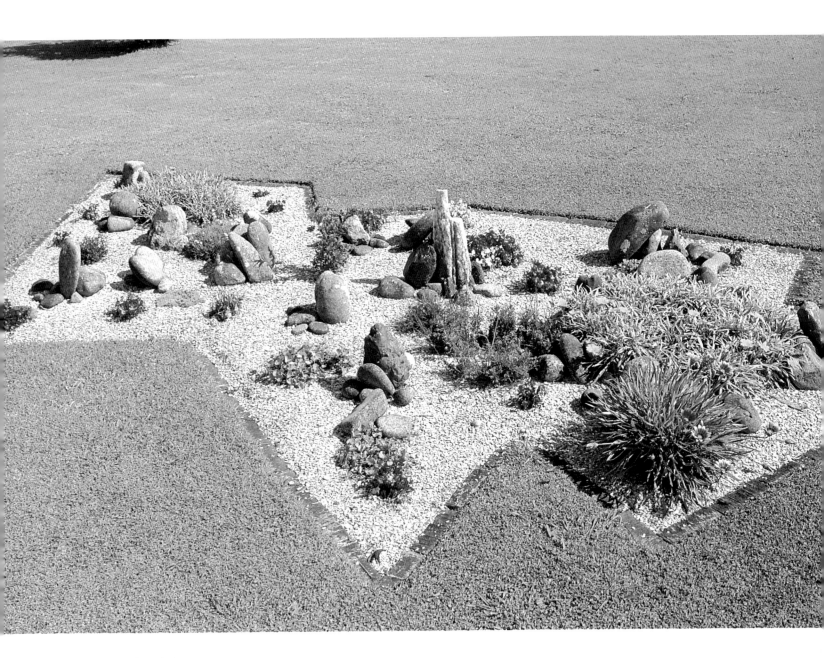

Auckland, April 1996

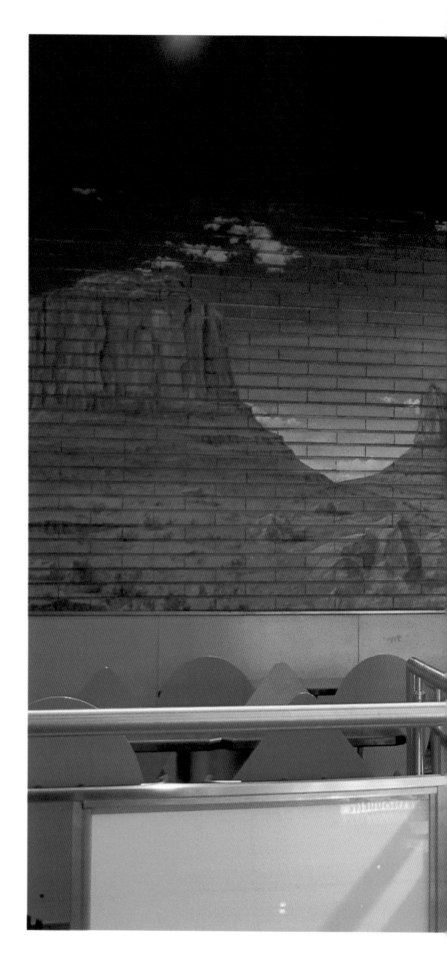

Paris, October 1996

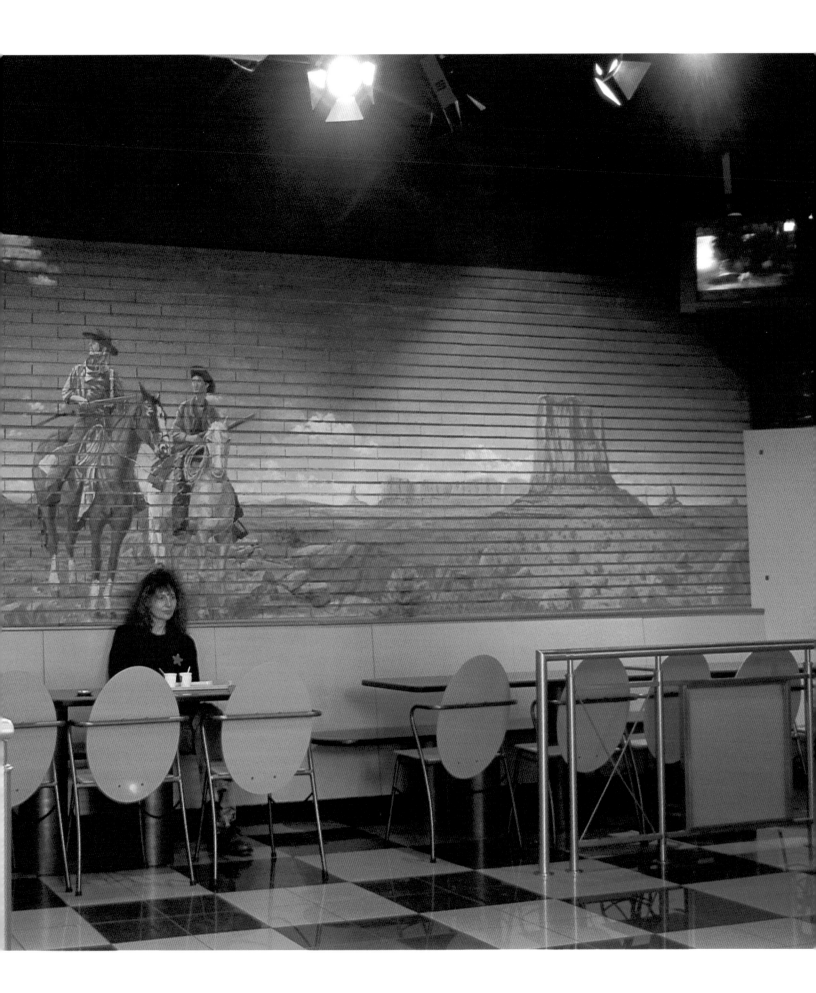

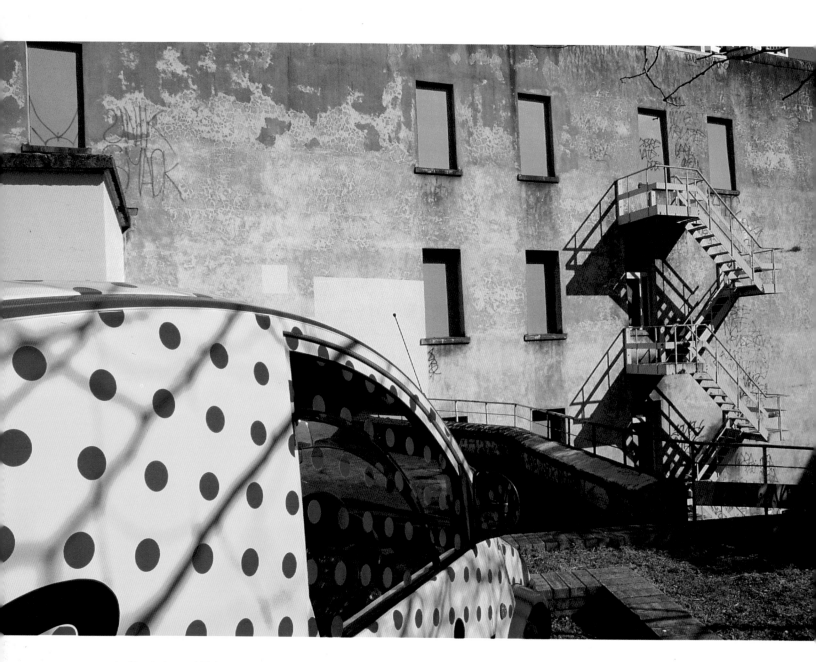

Auckland, August 1996

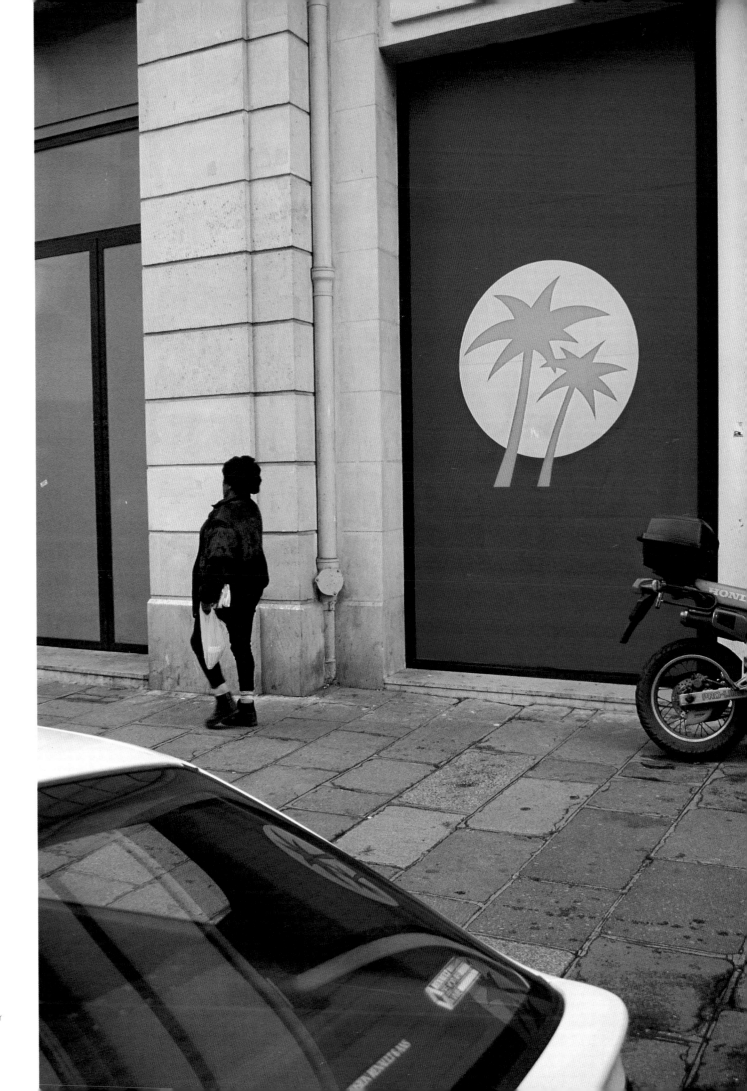

Paris,
October
1996

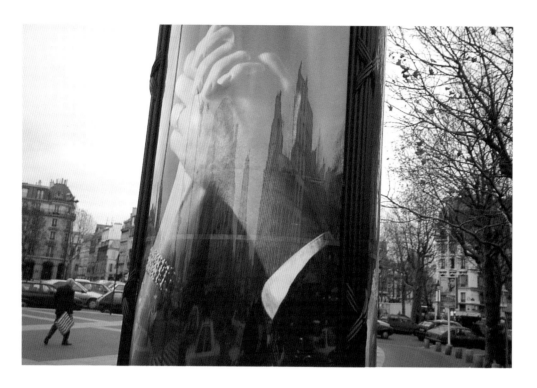

Paris, November 1994

Auckland, 1994

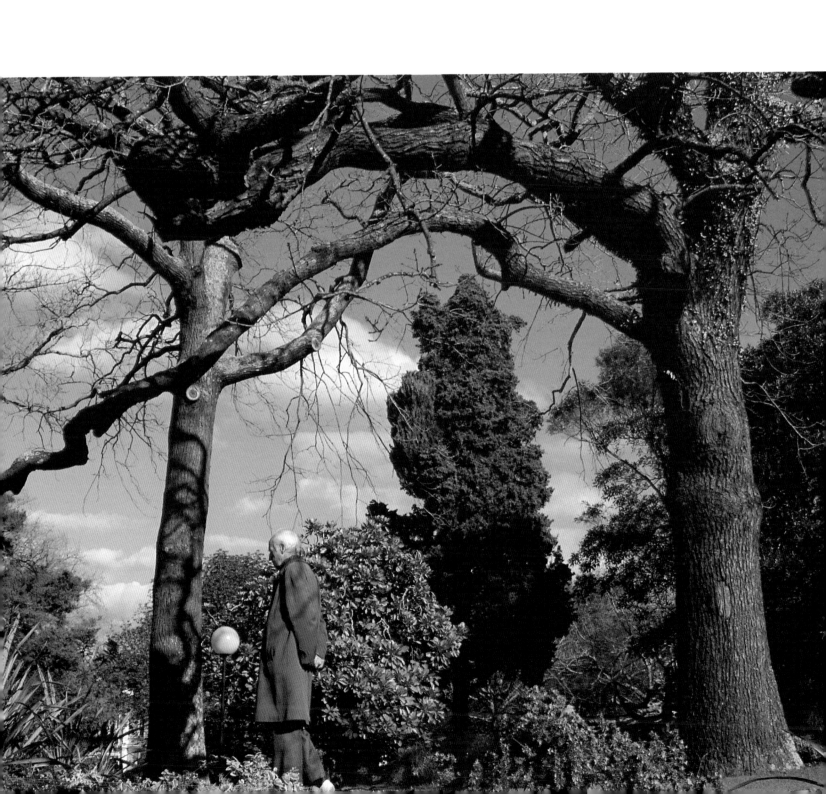

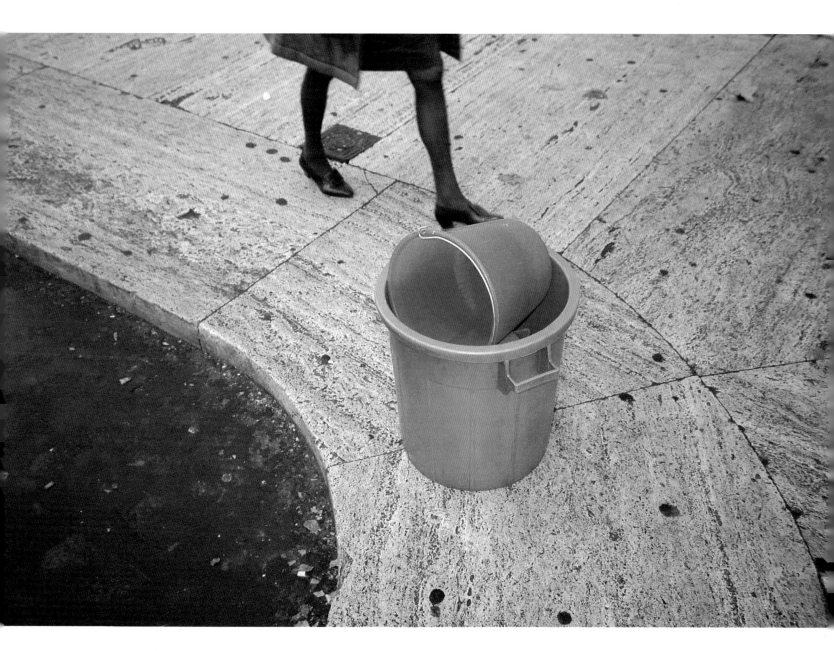

Rome, December 1994

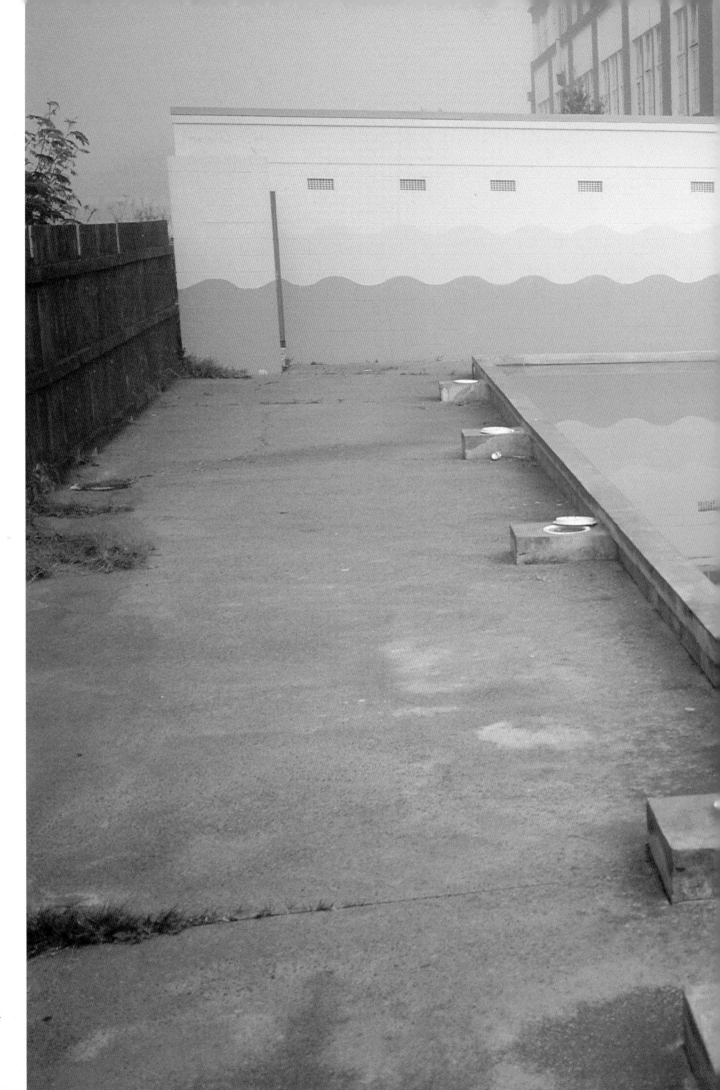

Auckland,
September
1995

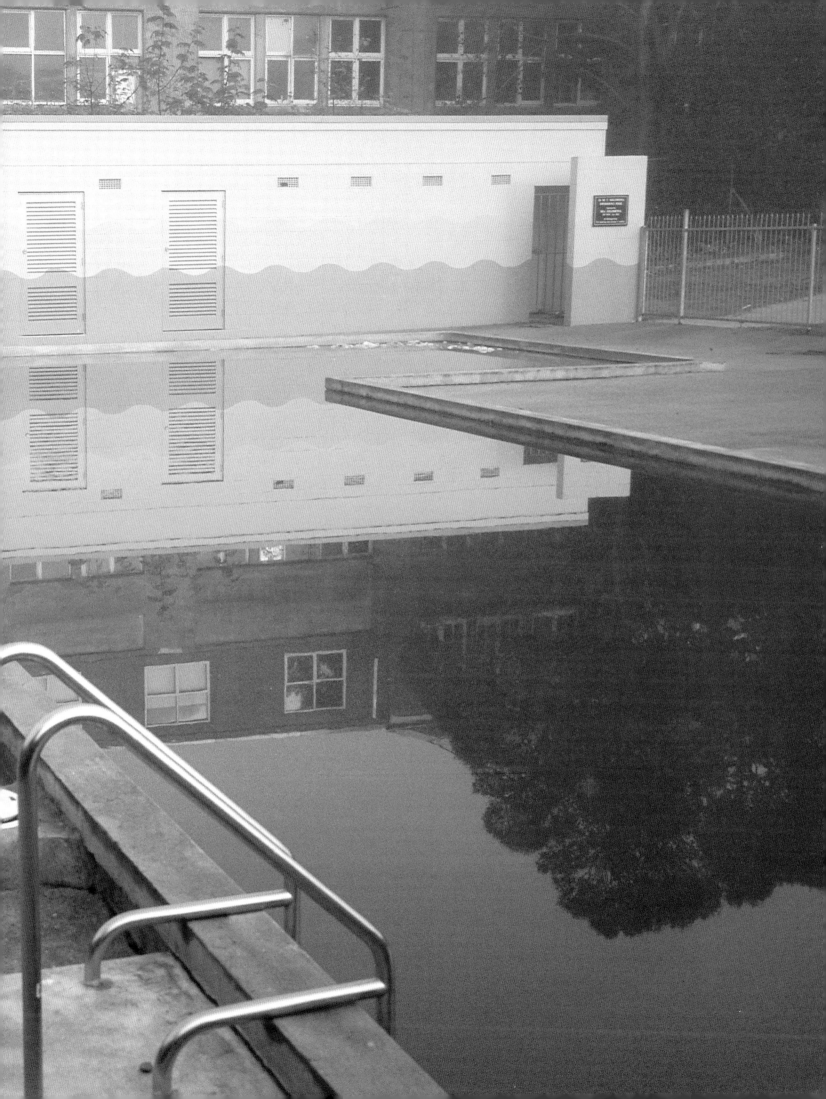

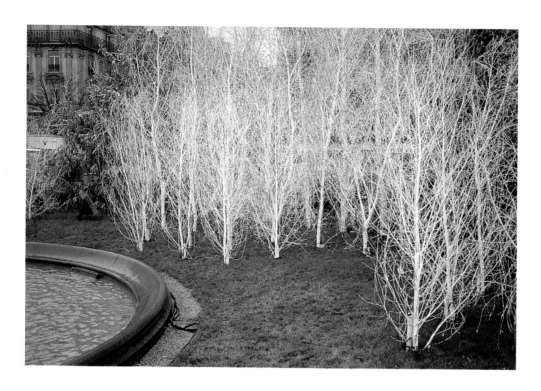

Paris, December 1994

Napier, March 1994

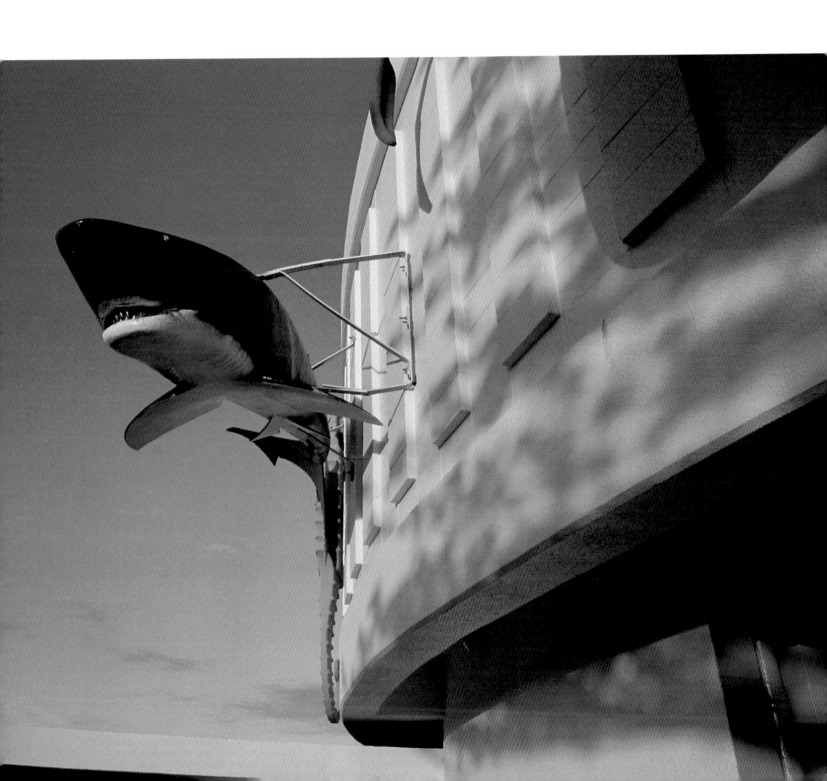

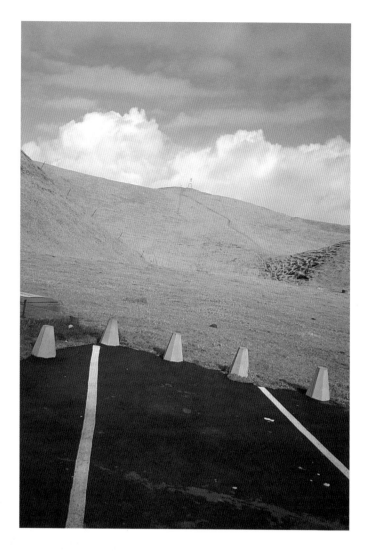

Auckland, July 1995

Sydney, August 1996

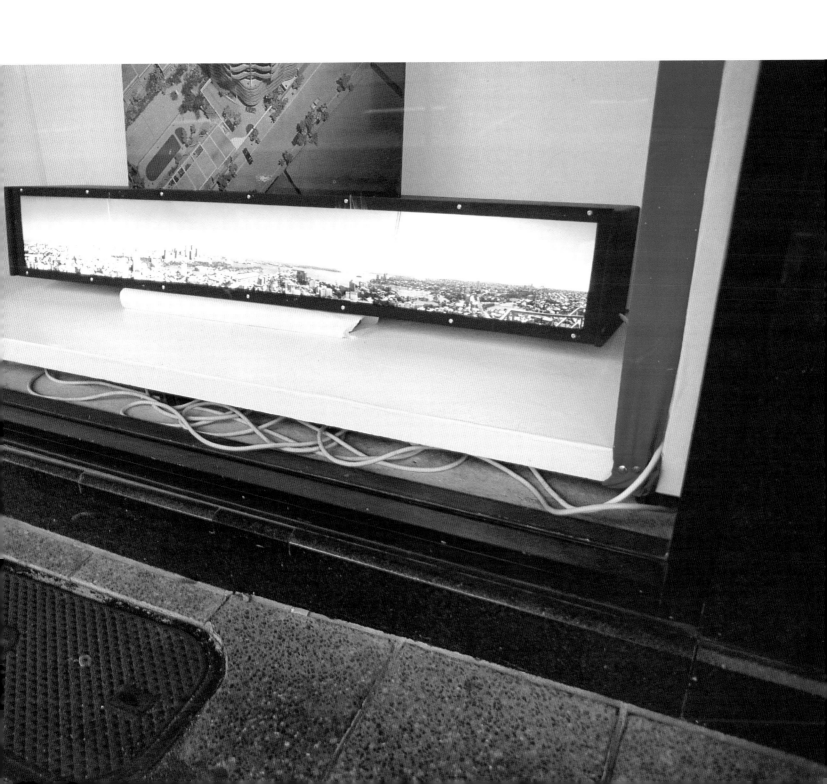

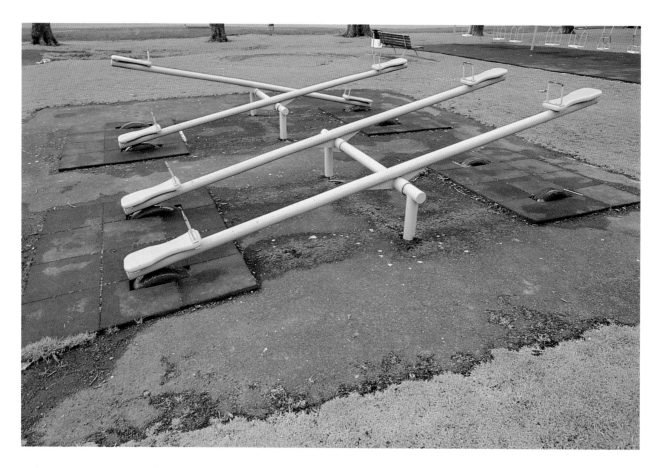

Auckland, October 1993

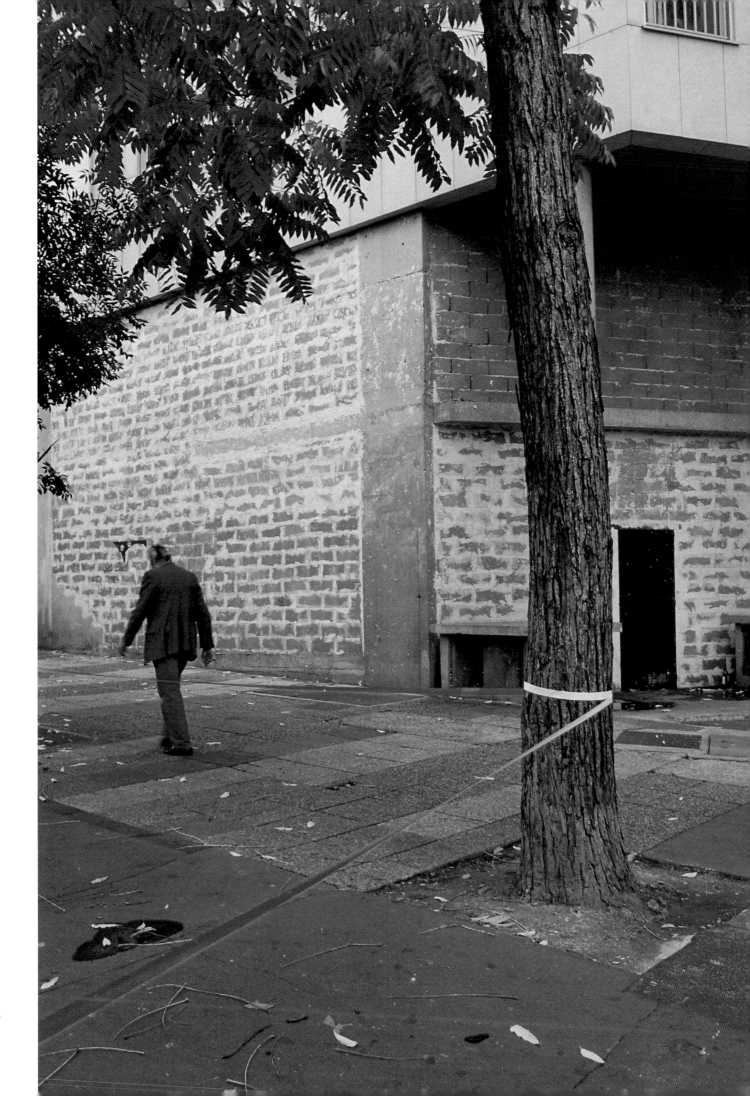

Paris,
October
1996

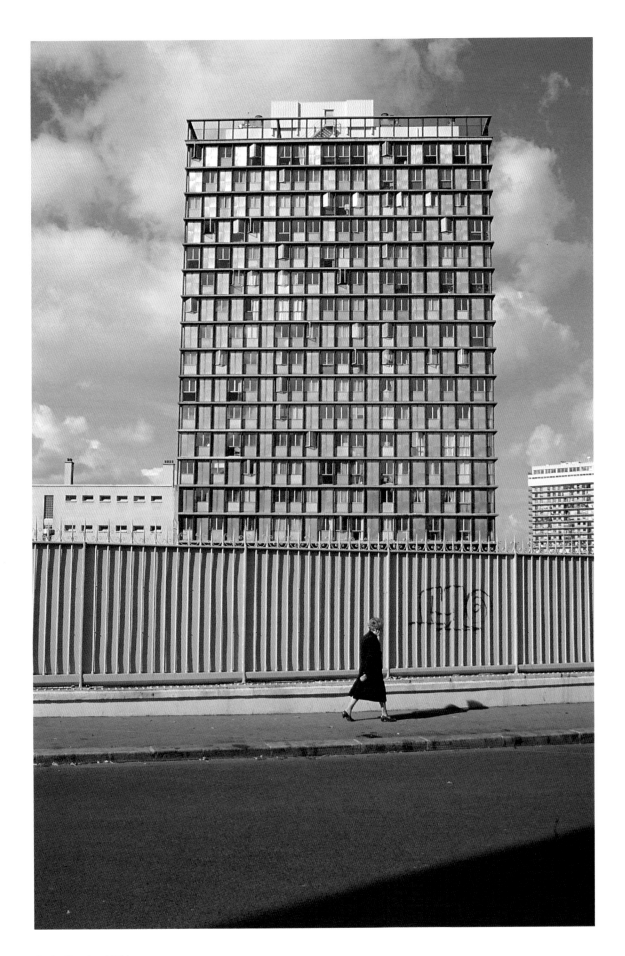

Paris, October 1996

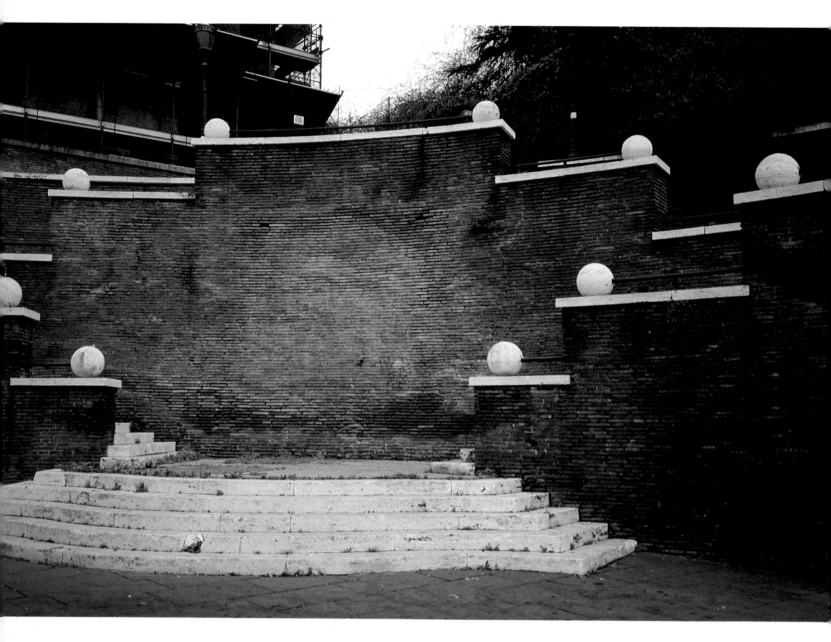

Rome, December 1994

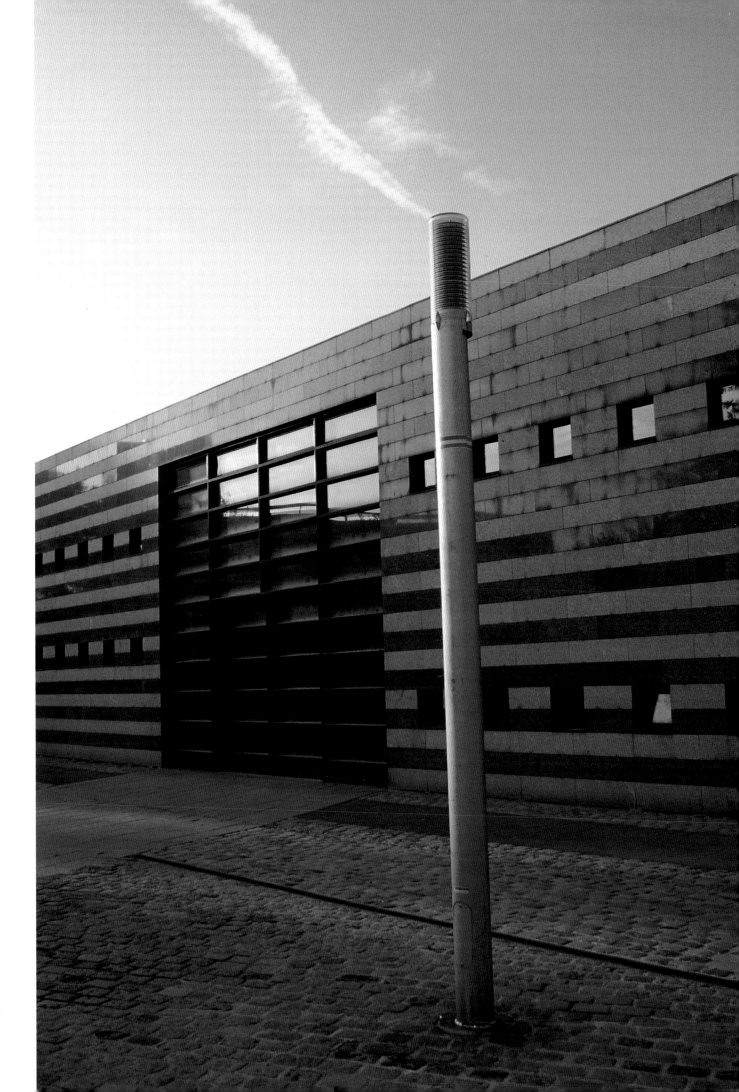

Paris,
October
1996

Paris,
October
1996

I would like to acknowledge all those who have given their invaluable support and advice during the making of this work. In particular I want to thank:

Gareth Abbott, Serge Aboukrat, Stephen Barnett, Christian Boyer, Ron Browson, Jocelyn Carlin, Matt and Fi Flynn, Jill Godwin, Charles Goulding, Roger and Shirley Horrocks, David Hurn, Christopher Johnstone, Christophe Léger, Mary-Ann Lewis, Dewi Lewis, André Magnin, Dolorès Marat, James Mok, Claude and Marie-Laure Piana, Sue Reidy, Ross Ritchie, Jane Sutherland, Dianne Taylor, John B. Turner, Peter Turner, Michael von Graffenried, Anouch Walicki, Geoff Walker, Esther Woerdehoff, Regan Yelcich.